BILL CUNNINGHAM
was there

BILL CUNNINGHAM
was there

spring flings + summer soirées

JOHN KURDEWAN + STEVEN STOLMAN

FOREWORD BY RUBEN TOLEDO

Rizzoli
NEW YORK

New York · Paris · London · Milan

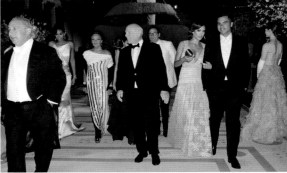
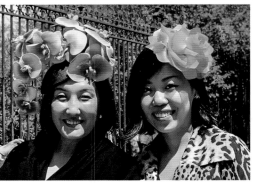

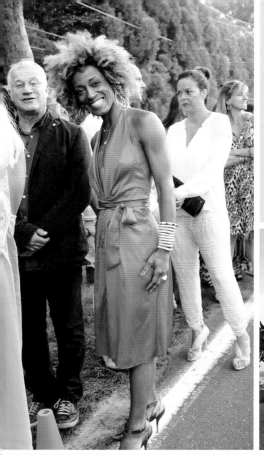
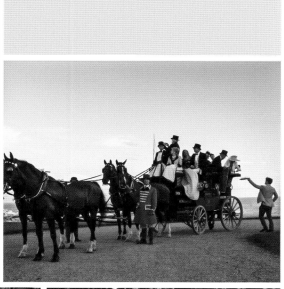

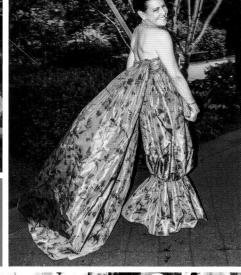

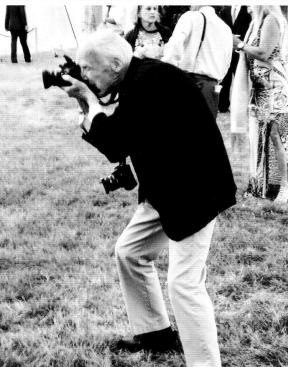

FOREWORD

RUBEN TOLEDO

BILL CUNNINGHAM'S journalistic coverage of the fashion and social scene in New York City revealed an enchanted fairyland. His point of view and accounts of day and evening social events were as charming, surprising, humorous, and endearing as he was.

Bill traveled like the wind on his bicycle, appearing here and there like an after-hours pixie at grand galas and fancy events, but he also showed up in the most unlikely places. He was a cross between a slightly bohemian Fred Astaire (minus the top hat and tails) and the hardworking photographer Weegee. He spoke like a swell, with an encyclopedic knowledge of fashion names and historical references, but worked like a dedicated craftsman.

With his superhuman sidekick, John Kurdewan, Bill methodically and carefully assembled his pictures while simultaneously constructing his story: a multicultural and diverse quilt of so many New Yorkers—some famous, some yet to be discovered, and some glamorously anonymous, but all wondrous and luminous, especially more so when captured by Bill's camera.

With this book, we get to sit next to Bill and learn how his extraordinary portrait of metropolitan life was pieced together weekly with love, sweat, tears, and loads of imagination. ▪

OPPOSITE *Isabel and Ruben Toledo, 2014.*

INTRODUCTION

JOHN KURDEWAN AND STEVEN STOLMAN

ARGUABLY ONE OF THE MOST influential fashion and society photojournalists to have impacted not just one generation but several, Bill Cunningham's life story and career were as cinematic as the images that he captured and edited for his two weekly features for the *New York Times*, "On the Street" and "Evening Hours." For thousands of oh-so-socials and fashionistas, along with the events that they attended, Bill's presence and ensuing coverage provided a certain kind of validation, proof that they were at the right place at the right time, wearing something distinctive enough to catch his unerring eye. Even in the digital age, when proof of presence is pretty much in everyone's own hands, no Instagram post or Snapchat moment could ever compare to the thrill of seeing oneself in one of Bill's columns. Indeed, a frequent gauge of the importance of any particular event would be determined by whether or not Bill Cunningham was there!

In the days and weeks following his death, the outpouring of love and appreciation for the legacy of Bill Cunningham came in as many ways as his extraordinary life touched the countless individuals who felt a connection to this truly rare man. From renowned fashion designers, fellow journalists, and leaders of society to the anonymous people on the streets whose unique style caught his eye, everyone wanted a piece of Bill to keep close to their hearts and minds. Books have been written, articles published, and films made, all in the attempt to hang onto his magic—his relentless pursuit of beauty and the documentation of fashion as he witnessed it. His body of work indeed justifies this intense interest, as no other individual ever has or ever will be able to do what this one solitary man did in his time on Earth.

Working alongside Bill at the *New York Times* presented an intense dynamic. Those who were lucky enough to have interacted daily with him didn't view him as an icon, but rather as a kindhearted, albeit eccentric, colleague who zipped in and out of the office with treasures held in his cameras. He'd sneak in a coffee or a doughnut, would make heartfelt inquiries about people's families and their lives outside of the office, but would always be drawn back to his work—that never-ending cycle of celebrating the art of dressing.

This book hopes to bridge the gap between the man and the myth, from the unique vantage point of a longtime colleague and dear friend, accompanied by the reflections of another fellow worker bee in the fashion industry. To say that Bill Cunningham is missed states the obvious. He was loved and admired by many, and he returned that love throughout his long career with a body of work that will forever be a cause for celebration. ∎

OPPOSITE *Bill Cunningham, Spring/Summer Fashion Week, Paris, 2013.*

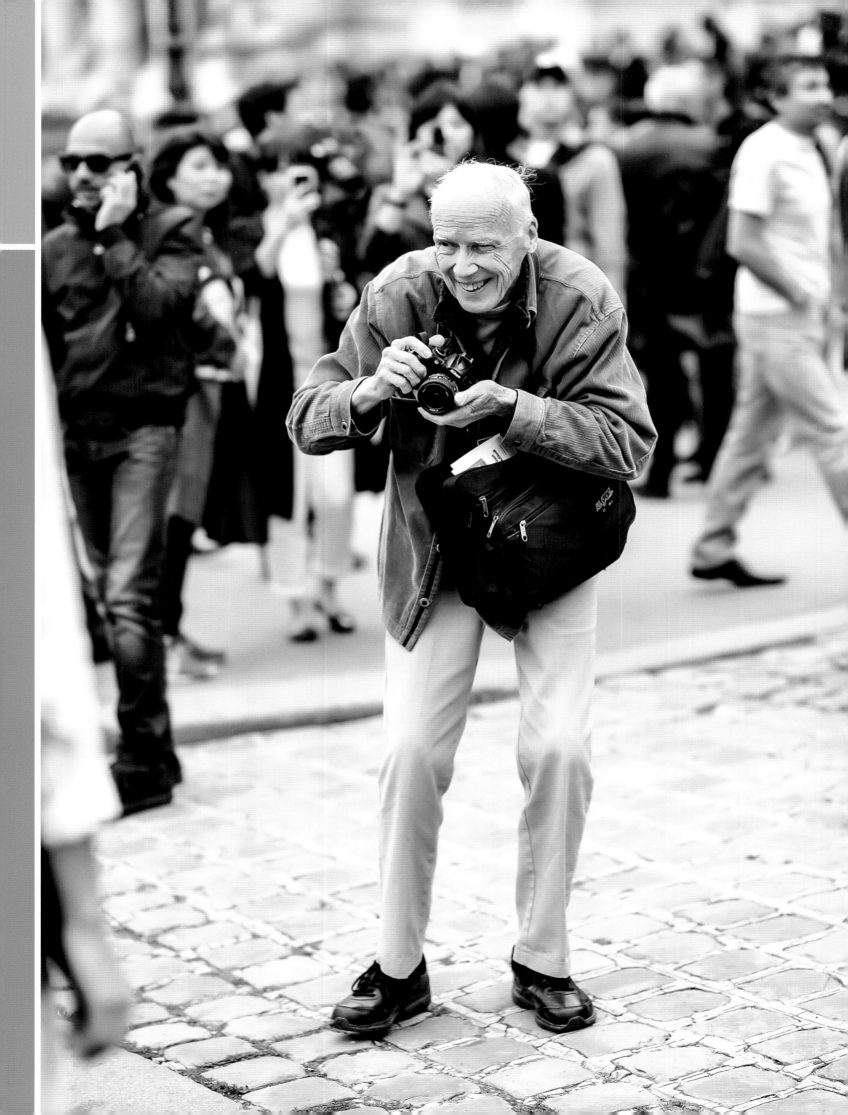

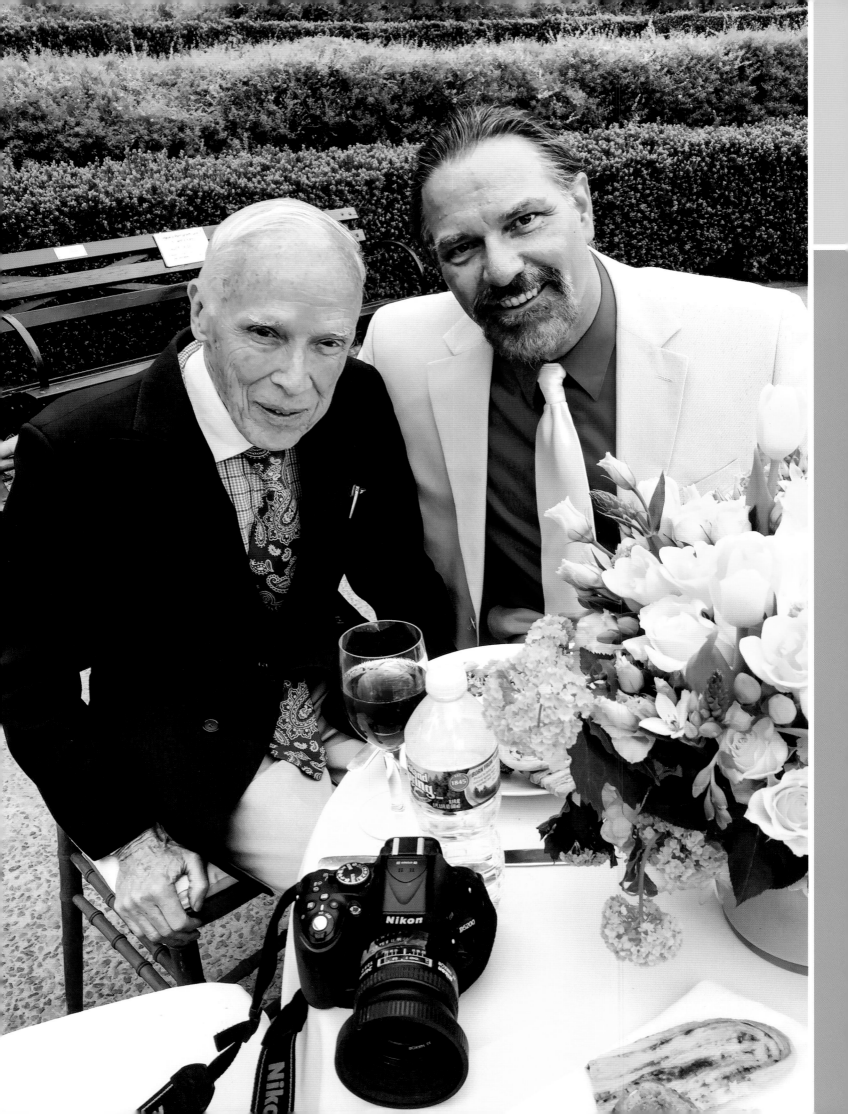

Working for Bill

JOHN KURDEWAN

I WAS BORN and raised at the Jersey Shore to a family very much like Bill Cunningham's—modestly middle class and devoutly Roman Catholic. Bill and I would always joke that as different as we were, we were basically cut from the same cloth. He spent childhood summers among the weathered beach cottages of Boston's South Shore; I had the slightly more colorful surroundings of boardwalks, French fry stands, amusement parks, and an awful lot of salt water taffy. And while Neptune, New Jersey, is about two hundred seventy miles south of Marshfield, Massachusetts, where Bill's family owned a summer house, it's the same ocean and, in many ways, the same culture. Faith, family, and work took precedence above all else—even at the beach.

Where we really differed in our upbringing was in the opportunities afforded to us after graduating from high school. Bill was offered a scholarship to

OPPOSITE *Bill and John Kurdewan at the annual Frederick Law Olmsted Awards Luncheon to benefit the Women's Committee of the Central Park Conservancy, 2015. One of the few times Bill agreed to eat at an event that he was covering (due to a spell of hypoglycemia).*

Harvard College. I was offered a job on a Coca-Cola delivery truck. While I consider myself in pretty good shape and played offensive lineman for my high school football team, the prospect of a lifetime of heavy lifting wasn't all that exciting to me. Fortunately, I had an alternative: my older brother worked at the *Asbury Park Press* and said he could get me a job as a photoengraver. I jumped at the chance.

I loved my years at the *Press*. In the early 1990s, it was the second largest daily newspaper in the state, and experiencing dynamic changes. The days of hot metal typesetting were coming to an end, as the new technology of desktop publishing began to take hold. While I was never a great student in school, I found that I had an affinity for this whole new discipline. On my own, I began studying all of the relevant computer programs, practicing at home and then gingerly using them at work. It was all a bit strange, as if I had discovered a new language that I immediately could understand. My supervisors took notice, and not only gave me more responsibility in the production of the

paper but also asked me to help others who were struggling with the transition to the digital age. I must say I loved showing seasoned newspaper people the possibilities that accompanied this significant shift in how things were done. But I also got antsy. By then, I had risen from apprentice to journeyman. Through the grapevine, I heard about an opening for a digital production artist at the *New York Times*. I thought, "Go big or go home," and applied for the job. I'll never forget the day that I was called in for an interview. I took the train up to New York and, upon returning home, received a phone call from the *Times* with a job offer. That was more than twenty years ago, and I haven't looked back since.

I was assigned to the photo department. There, we all worked in a sort of bullpen of individual workstations. There was something called "the bucket," which was actually a bin that held all of the photos that needed to be scanned and retouched. It didn't matter whether they were news, sports, food, or fashion—we would just grab from the top and work our way down until the bucket was empty. More seasoned production artists would do a little picking and choosing.

Most of us were all too swamped with our scanning, retouching, and color

correcting to care who was filling the bucket and when. But every once in a while, I couldn't help but notice this odd little guy—slender and sprightly, wearing either a bright blue jacket or a parka—who would zip in with a stack of photos and then disappear. Sometimes he even had a bicycle with him. Of course, I soon learned that his name was Bill Cunningham, and that he could be a real pain in the butt. Because he was covering social events at night and insisted on having his film processed offsite, he would always deliver his photos late, many times dangerously close to deadline. Worse than that, though, was his habit of requesting—no, demanding—substitutions of photos that we had already scanned into the system. This behavior earned him the nickname "King of the Subs." It was as if he were constantly editing himself, thinking that maybe there was a better picture, a more flattering pose. Sometimes, he would throw out his whole piece and come in at the last minute with all new images. To some in the bullpen, his process was maddening, as well as comical. But I found it intriguing and was always happy to stay late and help him make sure that the photos that he ultimately wanted would run. I honestly don't think Bill knew my name back then; he just called me "Young Fella," which is what he called pretty much every guy.

With time, Bill did get to know me better and took a shine to me because I never seemed to get flustered by his eccentricities or demands. I would be lying if I didn't admit that I enjoyed working on pictures of beautiful models during New York Fashion Week or after Bill returned from one of his trips to Paris. But in much the same way that I was drawn to all of the new developments that came along with the introduction of computers into our industry, I realized that I was beginning to learn about things that I previously had absolutely no exposure to. I honestly never thought much about fashion or society. I dress in pretty much the same way that I have since high school—jeans and a random shirt and boots—and am actually rather antisocial, preferring the company of my dogs and, of course, family. And the world of billionaires and black-tie galas exists on an entirely different planet than my life in Brick Township, New Jersey. I must say, however, that I lived vicariously through Bill's photos, and started to listen to him as he described what he had seen and captured.

Bill had an extraordinary memory, and what memories they were! During one of my visits to his apartment in the Carnegie Hall Studio Towers, he reminisced about his many famous neighbors over the decades. He knew I was a big fan of Marlon Brando, and told me that while appearing on Broadway in *A Streetcar Named Desire*, the actor hid out in Bill's apartment after being mobbed by a group of women who had knocked his door down. "Kurdewan, do you think you could handle that?" he asked me. He recalled the times that Marilyn Monroe, whom he knew from his earlier career as a milliner, would come up to the apartment to try on hats, once with Joe DiMaggio in tow, who sat quietly in the corner drinking coffee and chain-smoking cigarettes. Some nights, he would sneak onto one of the upper balconies to hear Leonard Bernstein conducting the New York Philharmonic. The best story, however, was how Judy Garland, after a night of partying, went up to the roof at two in the morning and started singing. Even at that late hour, people opened their windows to listen and applauded the impromptu performance. None of this celebrity seemed to ever faze Bill. "Child," he said, "you have to treat everyone equally."

I continued in my role at the *Times* for about a decade. It took another technological development to change that. The paper, still referred to as the "Gray Lady," was one of the last major dailies to start printing in color, mainly because management didn't feel that the technology was up to speed yet, and they were right. I still see far too many newspapers with color photos out of registration or otherwise distorted. But we did get there eventually. And this meant that Bill would need to start shooting with a digital camera. Anyone who has ever tried to teach a parent how to use an iPad understands this; someone who has used a certain technology for their entire life doesn't have the easiest time adjusting to a whole new way of doing things. So I was assigned the task of helping Bill migrate to digital photography. We found a camera that was close enough to what he was used to, and used duct tape to cover all of the buttons we didn't want him to push. He still managed to completely shut his camera down every once in a while, but we eventually solved that issue, too—with more duct tape.

OPPOSITE *A printout of a typical "Evening Hours" page with the images numbered in red pencil pending captioning. A personal note of thanks in the upper margin for a job well done on a previous day's page (in this case a massive Paris roundup page, seen on pages 18–19) was an example of Bill's inveterate thoughtfulness, 2011.*

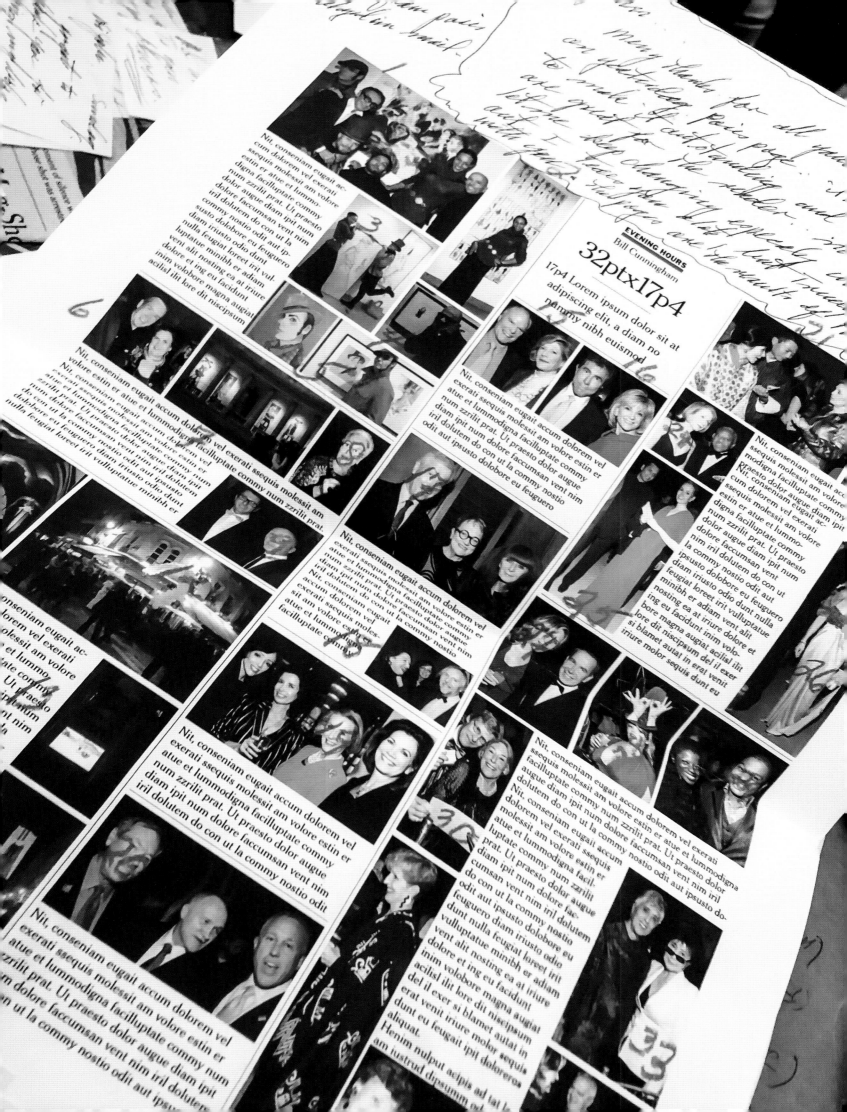

The real issue at hand was Bill's dramatically increased output. No longer constrained by rolls of film, and already prolific, Bill became absolutely giddy with his newfound ability to come back with not just hundreds, but thousands of images, each one slightly different than the next but, to him, essential in properly telling his story. At this point, management realized that the fiercely independent Bill would need help from someone who not only was technically savvy but also had the temperament to deal with his demanding schedule and, more important, his eccentricities. That task was assigned to me, and what initially started as just "holding down the fort" for Bill while he pedaled across his beat became a surprisingly collaborative effort. We built his pages side by side at my workstation, each one an individual collage of fashion and society as seen through Bill's lens. Soon, I began to understand what Bill experienced as socially ambitious folks hoped to find themselves in his weekly columns. The phone rang constantly; my email inbox became inundated with requests for Bill's attendance; and notes, flowers, and food arrived nonstop, the latter only to be discarded or sent to the break room for the rest of the staff to consume—Bill never indulged. In a sense, we were at war, faithfully trying to do our job while being attacked—by publicists, socialites, designers, and "regular" people trying to curry favor with Bill. I can't say that it wasn't interesting to observe or that Bill didn't enjoy some of the outreach, especially from those whom he truly liked and admired, but he held

fast to his ideals to remain independent, ethical, and unable to be bought. So I became his gatekeeper, doing my best to filter as much of the incoming noise as I could, while learning which contacts Bill would welcome.

As challenging as all of this sounds—and it was, especially as Bill began to experience the effects of age, ill health, and the seemingly endless bicycle mishaps—our joy in the work never waned. Every day, every download of images, every single edit and composition of a page was a delight, and never felt like work. We learned about each other and from each other in ways that went far beyond the workplace. We spent Thanksgivings together, and I accompanied Bill to certain events. In the ultimate expression of friendship, as explained by Jerry Seinfeld, I even helped him move. People joke about how certain coworkers can morph into "work-spouses," with relationships that rival the familial. And that's what Bill and I had. We were at various times best friends, parent and child, and soldiers in the trenches, depending on the day. Assisting the maestro in his masterpieces, which is how I view Bill's compositions, will forever remain the greatest honor of my life.

A lot of people continue to find it odd that I commute two hours each way from my home in New Jersey to my job at the *Times*. I never really think about it. As for the two decades that Bill Cunningham was in my life, the time just seemed to fly by. If I could have him back, for even just one day, I would walk the sixty-nine miles from my house to the *Times* barefoot. That's how much I miss working for Bill.

Building "the pages," as we called them, whether they were for Bill's "On the Street" or "Evening Hours" columns, was done in pretty much the same manner. Both would run every Sunday within the Sunday Styles section. "On the Street" was completely

fashion-focused and never identified individuals, but rather documented and discussed particular trends as captured by Bill on his daily rounds. "Evening Hours," however, was far more specific. It was a chronicle of the past week's major social events, with most, if not all, connected to charitable causes.

I would download the images from Bill's camera regularly to make sure that he always had enough memory available. I would then categorize the images by date, event, or subject matter, which was a "learn by doing" kind of thing. Many were obvious: puddle jumping, snowbank scaling, dogs, "twinning" (two people in the same outfit—usually ladies), blown-out umbrellas, flowers, black and white, to name a few. Others were more nuanced and took time for me to recognize, especially *le flou*, which was a Bill favorite. This was all about catching the dress in motion—usually lightweight fabrics such as chiffon or taffeta that would catch the wind and float behind the wearer. That a dyed-in-the-wool football jock like me learned to use words like "chiffon" and "taffeta" still tickles me. But I realized that, in order to do

OPPOSITE, CLOCKWISE FROM TOP RIGHT
Bill in his Central Park South apartment preparing to photograph the Macy's Thanksgiving Day Parade as it passed by his window; every year from 2011 on, he would host a buffet lunch for family and friends on the holiday. | Bill and John laying out a page. | "Conducting with a chopstick"—Bill indicating image placement during a working lunch; the chopstick method was developed to keep the monitor free of fingertip smudges from Chinese takeout. | Reviewing a final composed page for content, balance, and the all-important goal of storytelling, prior to the addition of text.

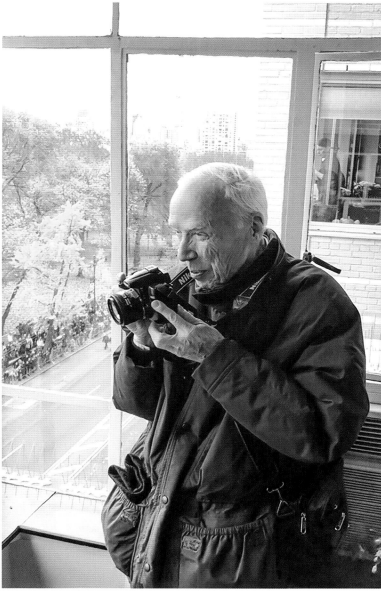

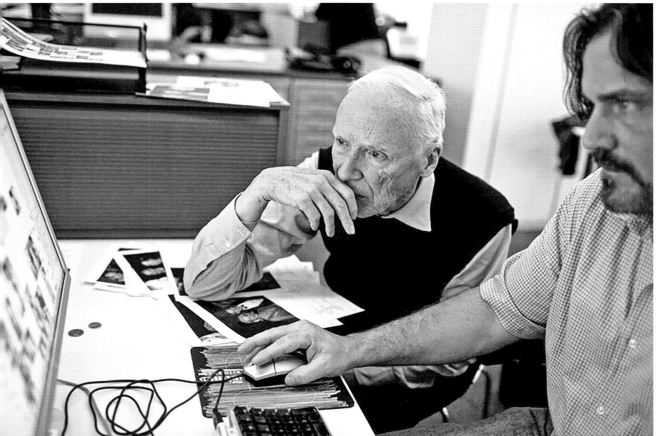

CLOCKWISE FROM RIGHT *Bill expressing appreciation to the team for his birthday party.* | *A new bicycle for his birthday in 2013: a step-through style for easier mounting; he was overjoyed.* | *Charming caricature dolls of John and Bill by fashion artist KahriAnne Kerr.* | *Bill hanging his beloved stained-glass parrots in the window of his new apartment overlooking Central Park, 2011.*

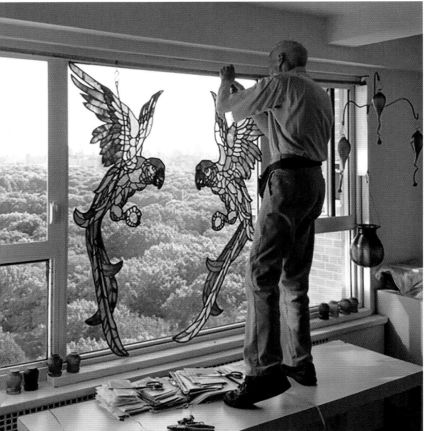

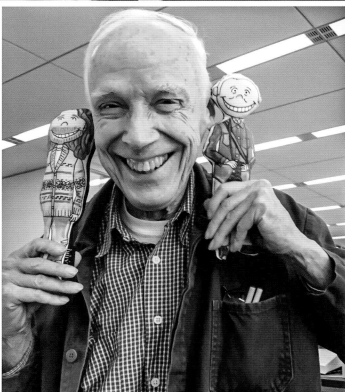

my job effectively, I needed to learn the lingo, and Bill was a willing teacher. There was always a story attached to an explanation, maybe even a recollection of, perhaps, "the most marvelous sheer gown that swirled in the breeze" at some charity event, or a memory of a famous dress from the Paris runways. I loved it when Bill became wistful. He would get this little twinkle in his eye as he recalled the exact moment when he first noticed the dress, many times also remembering who wore it, when and where. He had the most extraordinary photographic memory.

I would place all of the week's images on one side of my monitor, with a basic grid of the page on the other. I would add blocks of dummy text to indicate where Bill would eventually put his copy. He wrote it all himself, either longhand or by dictating it to someone on the copy desk, and I was always fascinated by his ability to write a clever headline that usually had some kind of double meaning. One of the best, I think, was for the triennial coaching weekend in Newport, where participants put on fancy historical dress and parade around town in beautiful vintage horse-drawn carriages. His headline? "Going Coach."

We usually scheduled our layout sessions around lunchtime, unless there was a big charity luncheon that day. Let's just say that Bill wasn't the best eater. He lived on food from the

corner deli, typical New Yorker things like fried egg sandwiches and a lot of coffee. He also liked Chinese takeout, especially the inexpensive lunch specials, so I would order in chicken and broccoli for both of us to eat at my desk while working on the pages. Bill resisted learning how to use a computer, and with me by his side, he really didn't have to. But during lunch, he would take his index finger and touch the screen, indicating which photos he wanted to go where. The end result was a monitor completely smeared with brown sauce. After wiping down my screen for the umpteenth time, I devised a plan. I grabbed a clean chopstick from the takeout bag and handed it to Bill. "Here, use this. Pretend you're an orchestra conductor." And that became our standard method of working together.

We often communicated through Post-it notes. Bill's handwriting bordered on illegible, but with time I learned to decipher it. He was a prodigious note writer (he would regularly write to his nephews), and I would find literally hundreds of notes to me on printed-out layouts, on my screen, on my desk, on my phone, and pretty much anywhere he could get them to stick. Each one contained so much more than just simple instructions regarding the composition of our pages. There were words of encouragement, gratitude for working on an especially difficult page, or snippets of his non-stop observations about the changing aspects of fashion, society, and the newspaper industry. So many people think of Bill Cunningham as only a

photographer, but he was actually an even better writer and a true wordsmith with an incredible command of language. I think this is most apparent in the videos for the *Times* website that he would record with the wonderful Joanna Nikas, when he would provide a running commentary of the trends showcased that week. He rarely work from notes. Instead, he would just speak extemporaneously, looking at a printed-out version of that week's page. These pieces are treasures, as we can hear his unique manner of speaking—that Boston accent that he never lost, even after more than a half-century of living in New York.

Many people continue to ask me if Bill had his favorites. The truth is, apart from a handful of luminaries such as Brooke Astor, the late philanthropist; Annette de la Renta, widow of fashion designer Oscar de la Renta; and Anna Wintour, Bill didn't really think about who people were. It was all about how they wore the clothes and their personal style, and he found merit in either outrageously expressive clothes or consistently well-turned-out ladies and gentlemen. He found beauty everywhere. I'm not saying that Bill was oblivious to popular culture—although he was completely uninterested in celebrities—but he did live in his own little world, much of it in the more elegant, refined past. I can't blame him. ∎

"Many guests wore wonderfully cut white shirts. Some balanced the white with black. Talk about drama!"

—BILL CUNNINGHAM

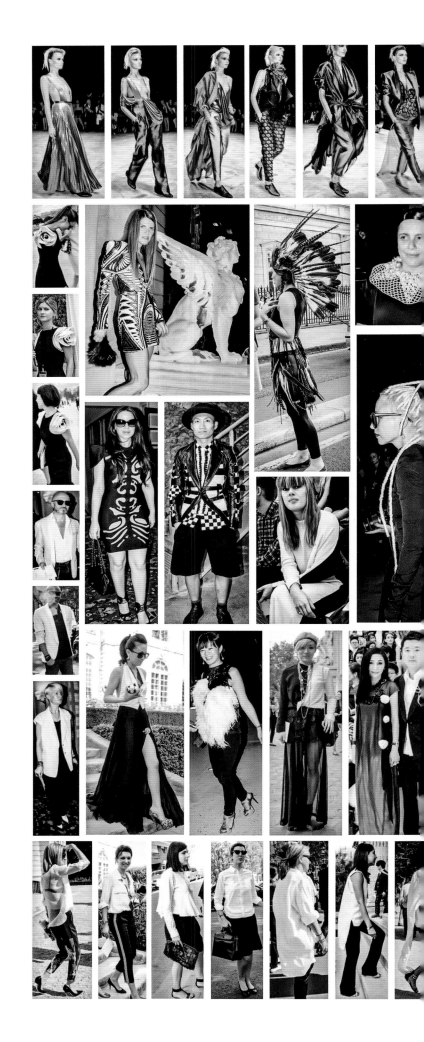

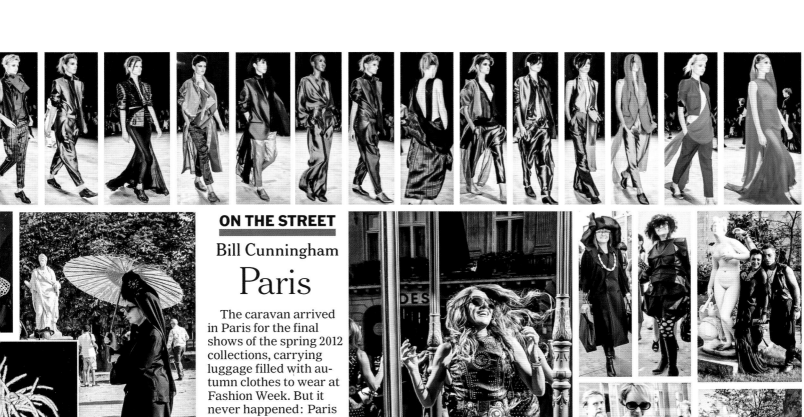

ON THE STREET

Bill Cunningham

Paris

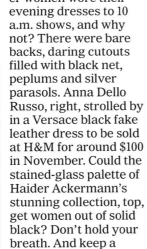

The caravan arrived in Paris for the final shows of the spring 2012 collections, carrying luggage filled with autumn clothes to wear at Fashion Week. But it never happened: Paris suffered a heat wave, and the guests stripped down. Chloé even rolled back the roof of the tent so the audience would not feel like baked potatoes. Many guests wore wonderfully cut white shirts. Some balanced the white with black. Talk about drama! Other women wore their evening dresses to 10 a.m. shows, and why not? There were bare backs, daring cutouts filled with black net, peplums and silver parasols. Anna Dello Russo, right, strolled by in a Versace black fake leather dress to be sold at H&M for around $100 in November. Could the stained-glass palette of Haider Ackermann's stunning collection, top, get women out of solid black? Don't hold your breath. And keep a white shirt handy.

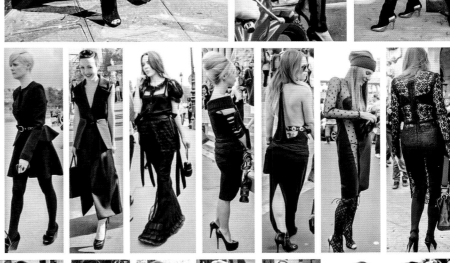

2

The Eccentric Aesthete

STEVEN STOLMAN

BILL CUNNINGHAM was a man of many talents. Designer, writer, photographer, photojournalist . . . there isn't one single word that can adequately describe him. "Friend" would be an even rarer word, for although he knew many people, few truly knew him. He wanted it that way.

Born to a middle-class Irish Catholic family in Boston, Massachusetts, William John Cunningham grew up in the kind of strict, faithful Depression-era household where children were expected to be seen and not heard. Even as a child, he showed a love for fashion, commenting later that for him, church was a welcome opportunity to observe women's hats. As a teenager, he got a job as a stock boy at the Boston branch of Bonwit Teller, beginning his exposure to the world of high style. And although he was awarded a scholarship to attend Harvard College in the late 1940s, he dropped out after only two months and moved to New York City at the age of nineteen, convincing his bosses at Bonwit's to secure him a place in the company's executive training program at the Fifth Avenue flagship. At first, he stayed with an uncle on Park Avenue, working in the

daytime and secretly creating fanciful hats by night in a studio that he had set up in an unoccupied maid's room. Sadly, when discovered by his patrician uncle, he was given an ultimatum: give up the hat-making nonsense or get out. He left.

Bill found a tiny apartment in a brownstone on West 52nd Street, and offered to clean the hallways in exchange for a reduction in rent. He also was able to secure a small studio on the ground floor of the building, where he proudly hung out a shingle for his millinery business "William J." With the help of Nona Parks and Sophie Shonnard, two friends who were the proprietors of couture salon Chez Ninon, and the financial backing of Standard Oil heiress Rebekah Harkness, Bill was able to build a large enough business to justify not only its own New York showroom but also a Southampton summer satellite in the 1950s. His designs were a favorite among the smart set, even attracting luminaries such as Katharine Hepburn and Marilyn Monroe.

But all was interrupted by a call to service from the US Army. Harkness demanded that Bill seek a deferral, but he was adamant to fulfill his obligation to his country, and borrowed the money to buy out his investor. As luck would have it, Bill was stationed

outside of Paris, and thereby got to know the City of Lights so expertly that he was asked to give tours to his fellow servicemen. While they would hit the Red Light district, Bill made a beeline for the museums, the grand boulevards, and the chic shops.

With a firm knowledge of Paris in his pocket, Bill returned to civilian life with a bolstered ego. He continued to design and manufacture hats and hobnob with high society. But it became clear to him that millinery was a waning business, thanks in part to the popularity of Jacqueline Kennedy's bouffant hairdo, which was adopted by almost every stylish woman in America.

He was a prolific, sometimes hyperbolic, writer. He boasted of his unique ability to discover fashion trends as they were happening, if not before, and was generally spot on. This gift for pointed observation, analysis, and commentary convinced a handful of major daily newspapers and magazines to take him on as a contributor, furthering his transition from milliner to journalist. These early columns for powerhouses, including the *Chicago Tribune*, reveal Bill as alternately glib

OPPOSITE *Bill Cunningham with muse Louise Doktor, Paris, 1980s.*

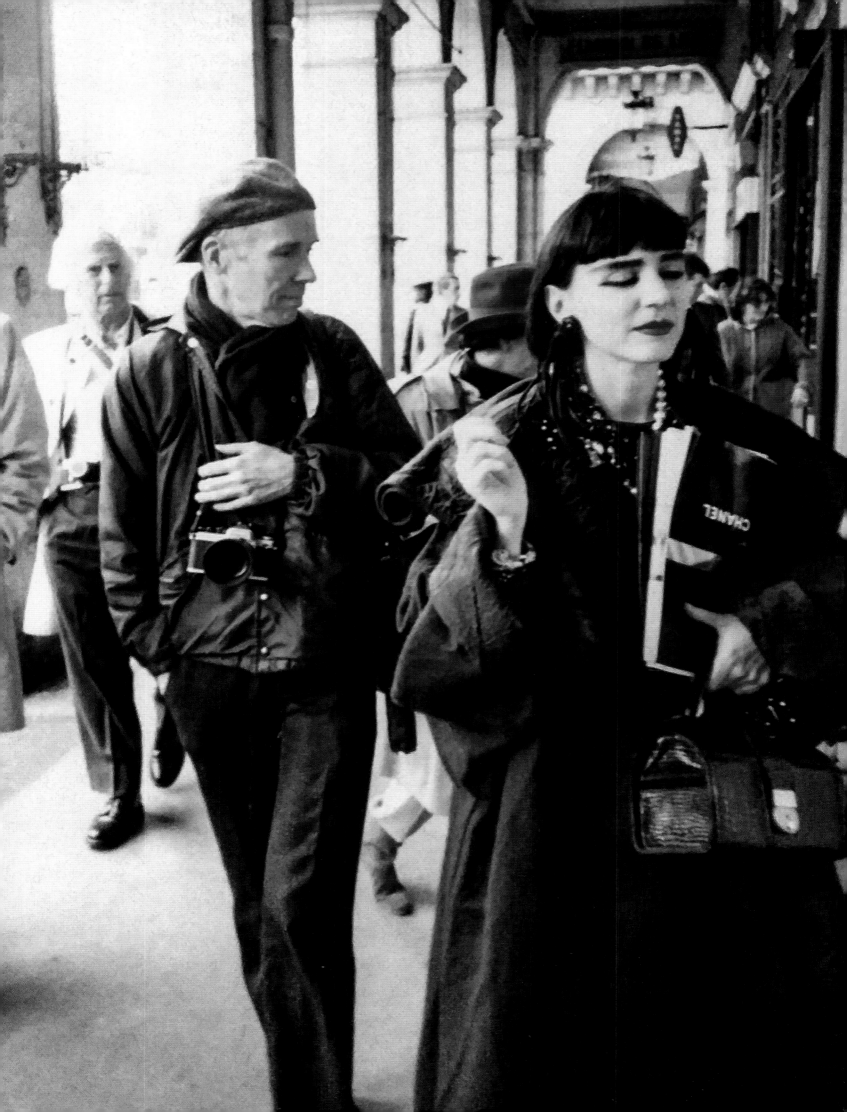

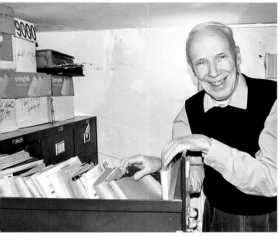

and gushy, but decidedly authoritative. In time, he was sought out by women's groups in various cities to lecture on the mode of the day, especially which Paris trends were making the transition to American ready-to-wear. He was a fashion savant and he knew it, as discussed in his musings about himself in his recently discovered manuscript *Fashion Climbing*. This fascinating manifesto, written at the beginning of Bill's career, provides a unique opportunity to experience his utter and total devotion to fashion and its place in history and society at large.

Bill's freelance fashion reportage caught the notice of John Fairchild, the mercurial publisher of *Women's Wear Daily*, the industry trade journal that was widely referred to as "the bible of fashion." By this time, he had begun to take photos with a modest little Olympus Pen D half-frame camera, given to him by fellow photographer David Montgomery, the first American to photograph the British royal family. While his association with *Women's Wear Daily* lasted only three months (it abruptly terminated over a disagreement with Fairchild regarding the importance of André Courrèges versus Yves Saint Laurent), Bill's career as a photojournalist took

off. Soon, he was a regular, albeit independent, contributor to the *New York Times*, a dynamic that remained until he had no other choice but to become a full-time employee in order to qualify for health insurance, following the first of his chronic bicycle accidents.

What began as a freelancer's regular contributions to one of the world's great newspapers ultimately ended as its own institution. Indeed, Bill Cunningham's complete body of work represents a comprehensive chronicle of not just fashion and not just society, but a unique visual and written record of how the two intersected in postwar and contemporary culture. ▪

OPPOSITE *Bill Cunningham with camera at the "Photo Cocktail Party," an event hosted by Antonio Lopez and Juan Ramos at the Robert Freidus Gallery in New York, 1979. Cunningham is joined by Lopez (upper left), model Pat Cleveland (front, with child on lap), and other friends.*

LEFT, TOP TO BOTTOM *Bill enjoying one of his new step-through bicycles, which served as his primary method of transportation on his beat regardless of time of day or weather. | Bill among his enigmatically organized files of negatives, contact sheets, prints, and notes at Carnegie Hall Studio Towers, 2010. | Bill with his great friend Toni "Suzette" Cimino, a floral designer whose clients included the renowned restaurant Le Cirque, 2011.*

FOLLOWING SPREAD *A May 2015 "Evening Hours" page illustrates how, even though well into his eighties, Bill amazingly covered fourteen events in one week. This was in addition to his weekly "On the Street" feature.*

Evening Hours
Bill Cunningham

May 18: The American Ballet Theater celebrated its 75th anniversary at the Metropolitan Opera House. A dinner for 1,100 guests followed. **1.** and **4.** Students at the company's school. **2. MISTY COPELAND** and **OLU EVANS**. **3. KALLIOPE KARELLA,** left, and **FE FENDI**. **5. MAXIM BELOSERKOVSKY** and **IRINA DVOROVENKO**. **6. HSIN-MEI AGNES HSU** and **OSCAR TANG**. **7.** From left, **JAMES WHITESIDE, ISABELLA BOYLSTON, REID BARTELME** and **LAR LUBOVITCH**. **8. ADRIENNE ARSHT** and **JOEL GREY**. **9. AMY FINE COLLINS**.

 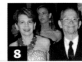 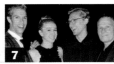

May 19: CITYarts, which engages artists and young people to create public art, held a reception at 1633 Broadway Avenue. **10.** From left, **STEPHANIE FRENCH,** an honoree; **TSIPI BEN-HAIM;** and **CHARLES BERGMAN,** another honoree. **11.** From left, **ALLAN McCOLLUM, LISA PHILLIPS** and **DAVID HALLBERG**.

May 19: The Metropolitan Museum's business committee handed out the civic leadership award at its spring gala. **12.** From left, **EDITH COOPER** and **KAREN PETERSEN MEHRA. 13.** From left, **ANNE, NATALIE** and **ALAN SCHNITZER,** an honoree. **14. AILE MOMOH,** left, and **TOLU ALABI. 15.** From left, **KIMBERLY WADE, KAHENA JAUBERT** and **TINA SUN**.

May 19: The Parkinson's Disease Foundation, which supports research and ideas that have the potential to improve the lives of those with the disease, raised funds at a spring dinner at the Metropolitan Club.

Willie Geist of NBC News was master of ceremonies. **16.** From left, **HOWARD, GINGER, KIP** and **MARIE MORGAN. 17. CURTIS ALAN** and **KATRINA BANKS**.

May 19: LifeWay Network held a benefit. **18.** From left, **SISTER MARY HEYSER, SISTER JOAN DAWBER, SHERYL WuDUNN** and **MARIANNE MOCARSKI. 19.** From left, **SISTER REGINA HOLTZ, SISTER JEANNE GILLIGAN** and **SISTER MARIE URSINO**.

The City That Never Stops

In mid-May, it seemed as if the parties were endless.

May 18: React to Film honored various directors at a reception at the Payne Whitney House. **20.** From left, **DENNIS** and **CORALIE PAUL** with **LOUIE PSIHOYOS** and **ORLANDO VON EINSIEDEL. 21. MELVIN VAN PEEBLES**.

May 19: Pratt Institute held an awards dinner that benefited a scholarship and education fund at the college. **22.** From left, **JAMES GAGER, LUCIA MAGNANI** and **MARC ROSEN**.

May 20: Steven Stolman celebrated his book, "40 Years of Fabulous: The Kips Bay Decorator Show House," at John Rosselli's shop. **23. BUNNY WILLIAMS** and **STEVEN STOLMAN**.

May 14: El Museo del Barrio presented a black-and-white gala at the Plaza hotel. **42. LUISA VILLEGAS, GARCIA QUIROZ. 44. EUGENIO LÓPEZ ALONSO** and **YOLANDA SANTOS. 45.** From left, **JANA PASQUEL DE SHAPIRO, JESSICA GARZA-BUERON** and **JORGE DANIEL VENECIANO. 46. JENNIFER VAUGHN MILLER. 47.** A guest ca the night's theme with a unique hat and handbag.

 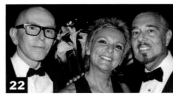

May 17: The Cancer Research In with a dinner at the Four Seaso aprons and filed through the kitc **24. LAUREN VERONIS,** who came u 33 years ago with Alex von Bidde McCULLAGH, left, and **MICHAEL R** MAROTTA served **JEFF** and **PEGAH** themes. **28. PAMELA JOYNER** and **C** the evening's auctioneer, and **PE** and **MR. VON BIDDER**.

May 20: chestra pr with dinn **31. CHRIS ARD BRUE TANAKA, a**

May 19: The Kaufman Music Cent dinner and performance at the Ec Ballroom. **33. ELAINE** and **HENRY K 34. GEORGIA STITT** and **JASON ROBE BROWN,** a Tony Award-winning co and lyricist.

May 18: The Ronald McDonald House packed the room for its awards dinner, raising $6 million. **35. ALIE GREAVES** with **ALEXA,** center. **36. KENNY** and **HA** From left, **BILL SULLIVAN, LOUISE CAMUTO, THALIA M STACEY BENDET**.

May 18: About 500 guests attended the 92nd Street Y's annual gala, raisin million. **38. SUSAN** and **STUART ELLMAN. 39.** From left, **MARC** and **LORI KASOW** HOWARD LORBER. **40. NAOMI SOLOMON,** left, and **MOIRA GALLAGHER. 41. STACE** MATTHEW BRONFMAN.

aised $1.42 million
urant. Guests donned
rving themselves.
he fund-raiser concept
DAN LITTMAN. 25. LOUIS
BERG. 26. GIUSEPPE
27. All the tables had
CALL. 29. JAMIE NEVIN,
Z. 30. JULIE MACKLOWE

heus Chamber Or-
d a performance along
e Metropolitan Club.
KI KELLOGG. 32. RICH-
left, and **MASAAKI**
ee.

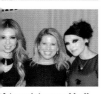

f Astoria's grand ball-
EDMAN, left, and **NAT-**
IMA with their son. **37.**
TINA LUNDGREN and

"In mid-May,
it seemed as
if the parties
were endless."

—BILL CUNNINGHAM

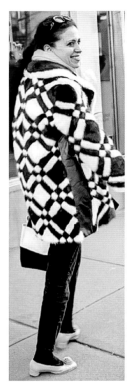

The New York fall 2001 fashion collections open today in the tents in Bryant Park. A recurring complaint of professionals for the last few years has been the cookie-cutter sameness of the collections and of department store selections. But one woman, Marilyn Kirschner, shown here in photos made in chance en-counters over the last year or so, doesn't like to look like everyone else. Three years ago, Ms. Kirschner, editor in chief of The Look On-Line (www.lookonline .com), a fashion Web site, started dressing almost exclusively in the "amazing things" she discovered at unbelievable prices in New York's thrift shops and

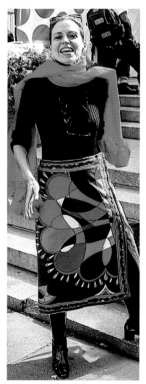

The Color of Money (In the Bank)

vintage sales (like the $200 Op Art-pattern mink coat, top left).

Her time-consuming hunting started with colorful vintage Pucci clothes, and 90 percent of her wardrobe is now vintage, except for her shoes, which are new classics. ''I need a whole bedroom just for bags,'' she said, like her 1950 bowling bag, worn with a $65 fur-collared tweed suit, third from right at top. The bag was $20 with the ball and $3 without (a current Prada bowling bag costs $700). ''You can wear anything if you have the eye for the right proportions. But when I travel out of the city I wear simple clothes, so I don't look odd.''

3

The Rites of Spring and Summer

WHILE NEW YORK CITY may be one of the most alluring and dynamic places on Earth with millions visiting and moving there every year, when the temperatures begin to rise and summer settles in, many residents flee to cooler, calmer places—some for a day, others for a weekend or even the entire season. Whether north to the hills of Connecticut and the Hudson Valley, south to the Jersey Shore, or east to the sandy beaches of Long Island, the ritual of decamping from the city is as much a part of New York life as riding the subway or grabbing breakfast from a coffee cart.

As early as the 1920s, society swells sought to keep their calendars full, even "in the country" as many New Yorkers still refer to almost any place within a few hours' journey from the city limits. They established private clubs for golf, tennis, swimming, and dining, and got involved in supporting local causes such as hospitals, museums, village improvement societies, and social service organizations. And when high society lends its support, it's usually accompanied by parties—galas, kickoffs to galas, and kickoffs to kickoffs. Social calendars started to appear, along with bold-faced names attending events, thereby attracting

the interest of the fashion and society press. And as these glamorous events began to multiply in the postwar world, Bill took notice.

With some regularity, Bill would hop a train on summer Saturdays to such places as Southampton and Millbrook to cover the parties. The longer journey to Newport might include a visit with his family at their summer house in Marshfield, Massachusetts, where Bill had his own little apartment over the garage. But mostly, for Bill, these were day trips, as house-guesting was something that he was loath to do. Regardless, he always managed to appear at the big evening events at just the right time, capturing the arriving guests in their finery or maybe later, on the dance floor. In the interest of economy, he might line up two or three events, perhaps the polo matches in Bridgehampton in search of fetching hats or examples of captivating day looks. He would also attend the annual Fitch's Corner Horse Trials in Millbrook, which was hosted by socialite Fernanda Wanamaker Niven and her husband, Kirk Henckels.

While Bill held Newport in a special place in his heart for its Gilded Age legacy, his connection to the great ladies of Southampton and their swanky soirées was truly special. He was especially drawn to Catherine di Montezemolo, famous at first for being one of the beautiful Murray daughters—the Murrays being one of the preeminent families of Southampton. But as a young adult, Cathy, as she was known, veered from the more predictable path of her contemporaries, that of marriage and motherhood, to become a junior editor at *Vogue*. There, she championed the work of such groundbreaking American fashion designers as Anne Fogarty and Claire McCardell, the true inventors of American sportswear. In later years, she was a fashion director for Lord & Taylor. Tall, slim, and naturally chic, she married an Italian marquis in 1958, and they became fixtures on the social circuit. To Bill, however, she was a "sister from another

OPPOSITE *At the Metropolitan Museum of Art's annual Costume Institute Benefit, also known as the Met Gala, the exhibition* Charles James: Beyond Fashion *inspired many attendees to wear gowns suggestive of James's unique structural style, May 2014.*

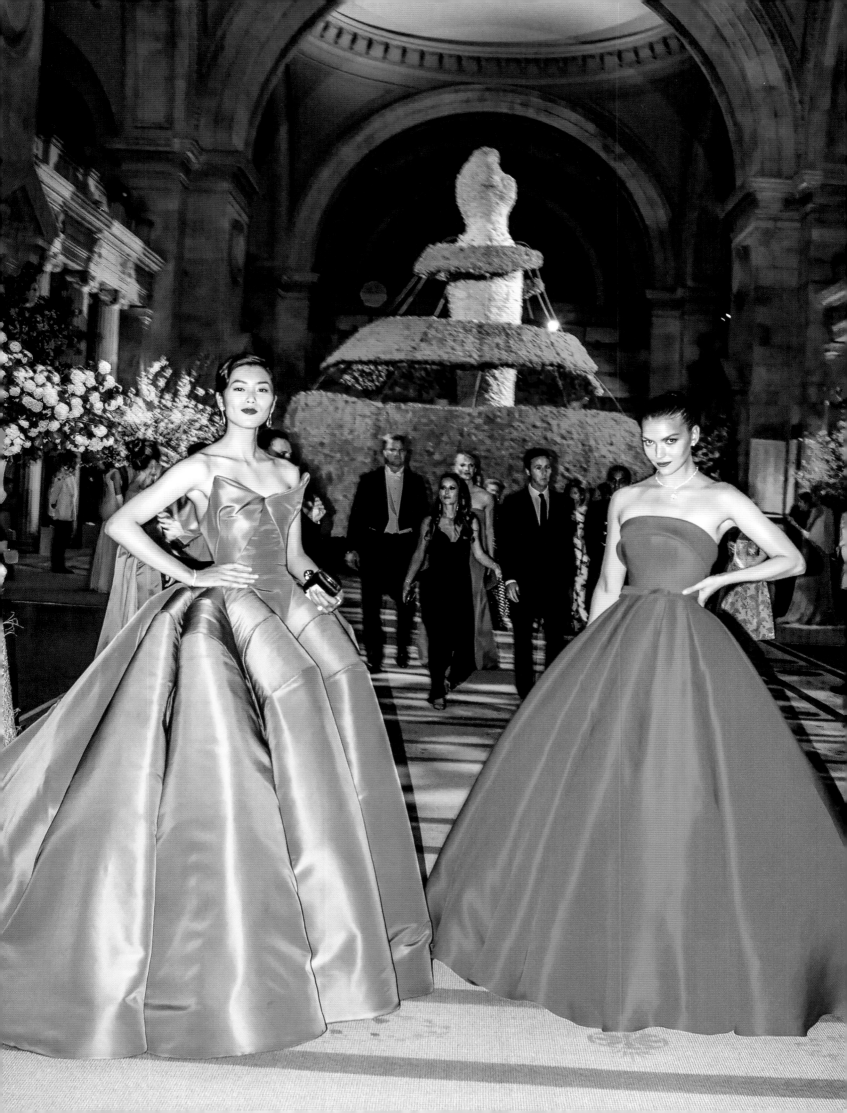

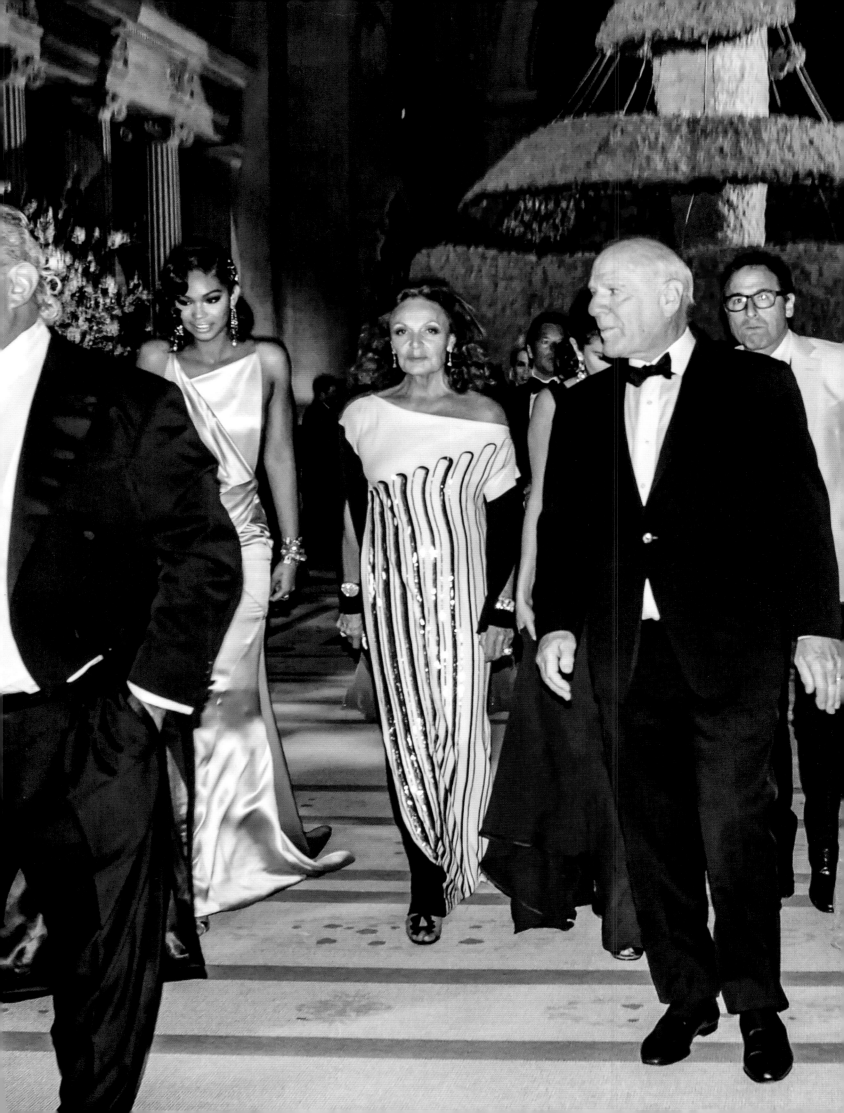

mother." In many ways, they resembled each other and even sounded alike. The affection between the two was obvious, and always apparent in his hundreds of photos of her.

The grand annual Summer Party to benefit Southampton Hospital, now known as Stony Brook Southampton Hospital, revealed Bill at his best. At its peak in the late 1990s and early 2000s, the event gathered up to fifteen hundred guests under two gala tents erected in a field belonging to the hospital. Like the Frederick Law Olmsted Awards Luncheon to benefit the Central Park Conservancy, the Southampton Hospital gala enjoyed a fixed place on Bill's "must do" list, except for every third year when it would conflict with the triennial Coaching Weekend, presented to benefit the Preservation Society of Newport County. Indeed, the special events staff of the then Southampton Hospital Foundation were acutely aware as to whether it was "a Bill year" or not.

Regardless of whether these events took place in New York City, upstate in places such as Millbrook and Saratoga, southwest in New Jersey, out east on Long Island, or further northeast in Newport and beyond, Bill tirelessly managed to—somehow, someway—fit them all in in his inimitably independent manner, always relying on public transportation for fear of ever showing any favoritism in his coverage. ▪

LEFT *Designer Diane von Furstenberg, husband Barry Diller, and actress Jessica Alba arriving at the Met Gala celebrating the opening of* Charles James: Beyond Fashion.

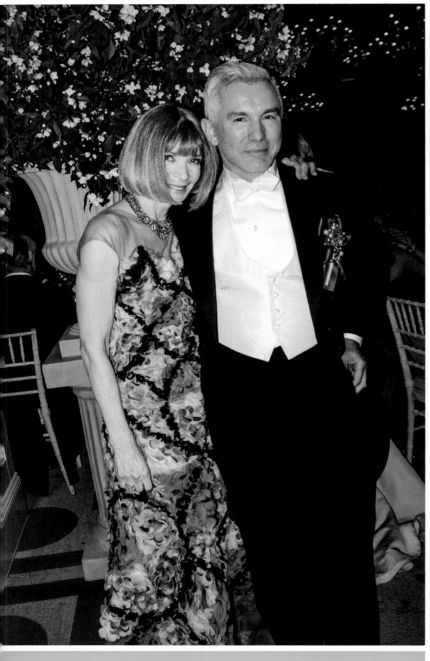

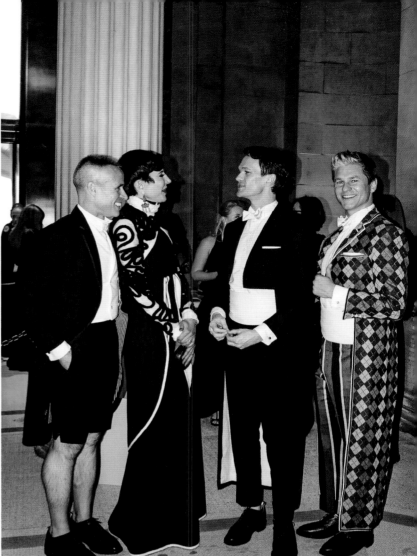

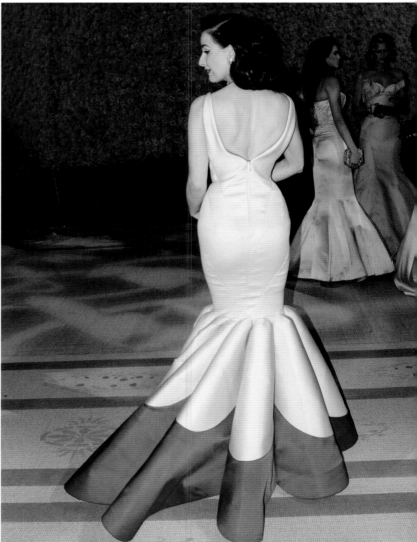

OPPOSITE, CLOCKWISE FROM FAR LEFT
Condé Nast artistic director and *Vogue* editor-in-chief Anna Wintour with Australian filmmaker Baz Luhrmann. | Designer Thom Browne in signature short pants with Amy Fine Collins; actor Neil Patrick Harris; and Harris's husband, David Burtka. | Dita Von Teese in a Zac Posen creation, 2014.

RIGHT A quiet moment, in sheer pink illusion with embroidered flowers, 2014.

BELOW A bevy of ladies in gorgeously colored gowns in keeping with the 2014 homage to designer Charles James, known for his dramatic creations.

FOLLOWING SPREAD Rihanna with fashion designer Stella McCartney, 2014.

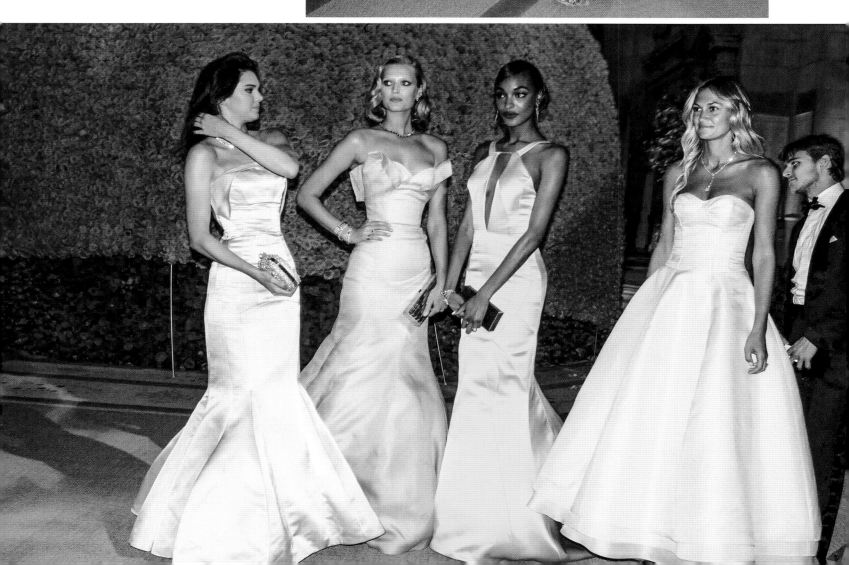

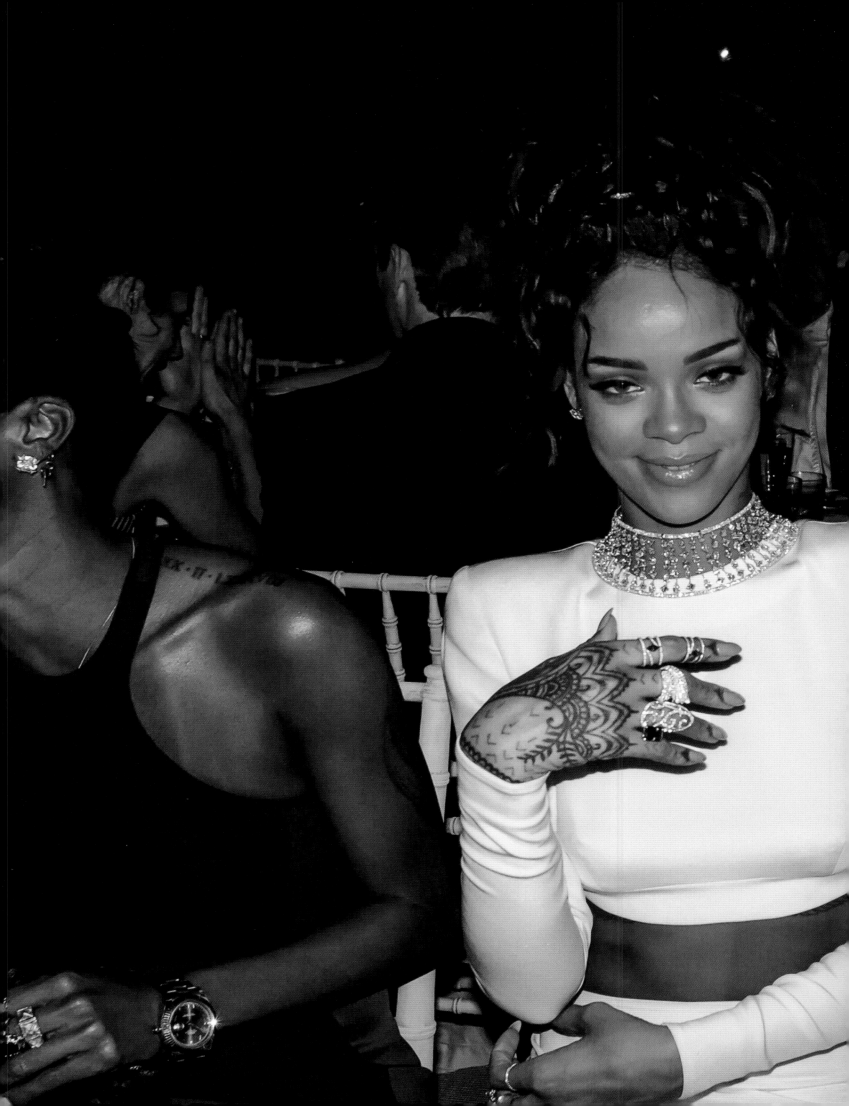

LEFT TO RIGHT At the Conservatory Ball to benefit the New York Botanical Garden, 2015: designer Carolina Herrera, Prince Dimitri of Yugoslavia, and Carolina Herrera de Báez. | Di Mondo and milliner Eric Javits. | Suzette Smith in an aquamarine organza gown. | Jay Diamond and Alexandra Lebenthal.

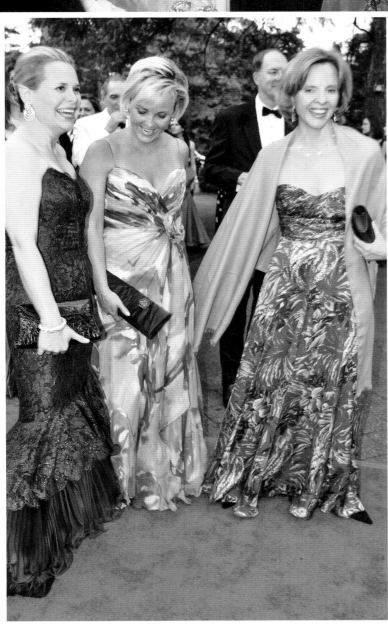

OPPOSITE Maureen Chilton, Caroline Williamson, Ann Johnson, Cosby George, and Gillian Miniter at the Conservatory Ball, 2014.

THIS PAGE, CLOCKWISE FROM LEFT A beaming Mai Harrison with Gregory Long, president emeritus of the New York Botanical Garden, 2005. | A spectacular floral display juxtaposed with gowns in similar colors. | A wave of purple on the red carpet.

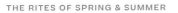

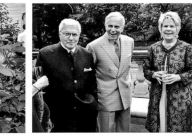

FLAMES IN THE GARDEN The annual Fifth Avenue lawn and garden party at the Frick Collection was an exceptional experience made only more so by the rarity of the Fifth Avenue garden that's part of the Gilded Age home. A painting was the focus of the festivities: "Flaming June" (above) by Fredrick Leighton, a Victorian artist and contemporary of James McNeill Whistler. It was shown alongside the Frick's four Whistlers. Some of the 600 guests wore the vibrant orange color of the painting. All of the guests made a big effort to dress for the occasion. Many of the Frick family members were present.

"Some of the 600 guests wore the vibrant orange color of Frederic Leighton's 1895 painting *Flaming June.*"

—BILL CUNNINGHAM

• • JUNE 14, 2015

41

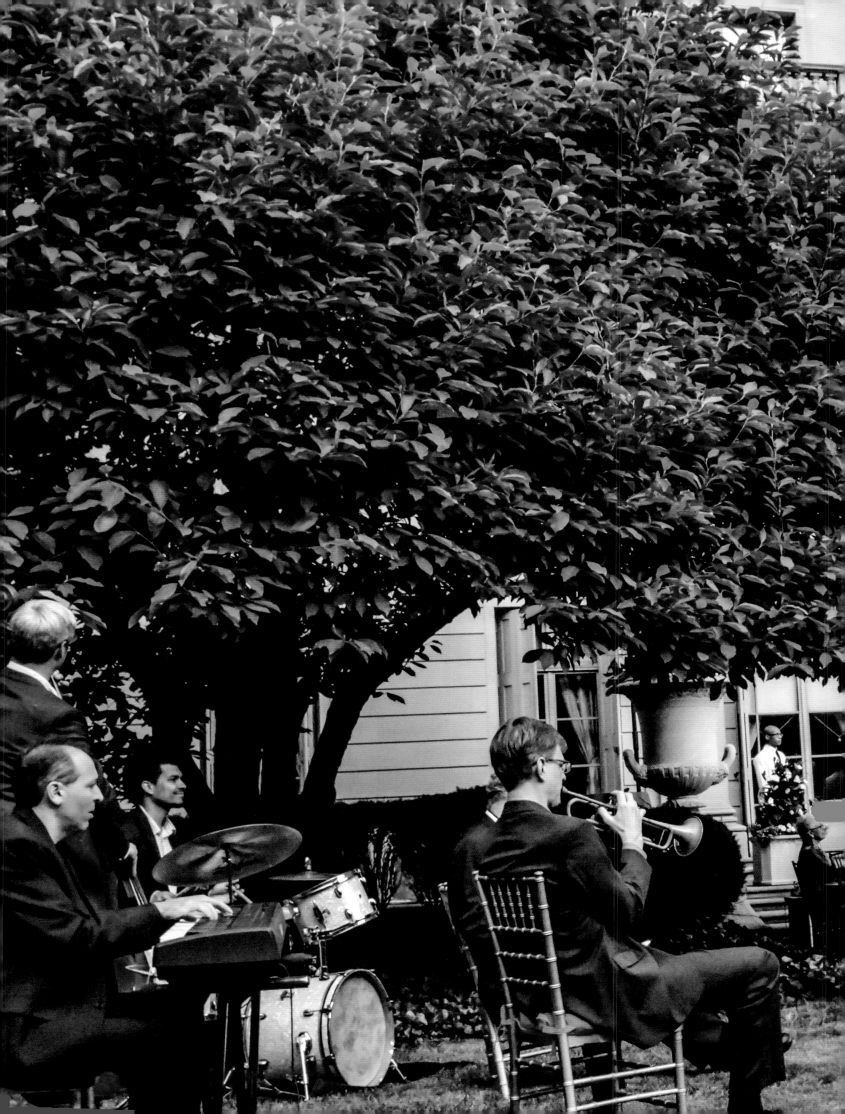

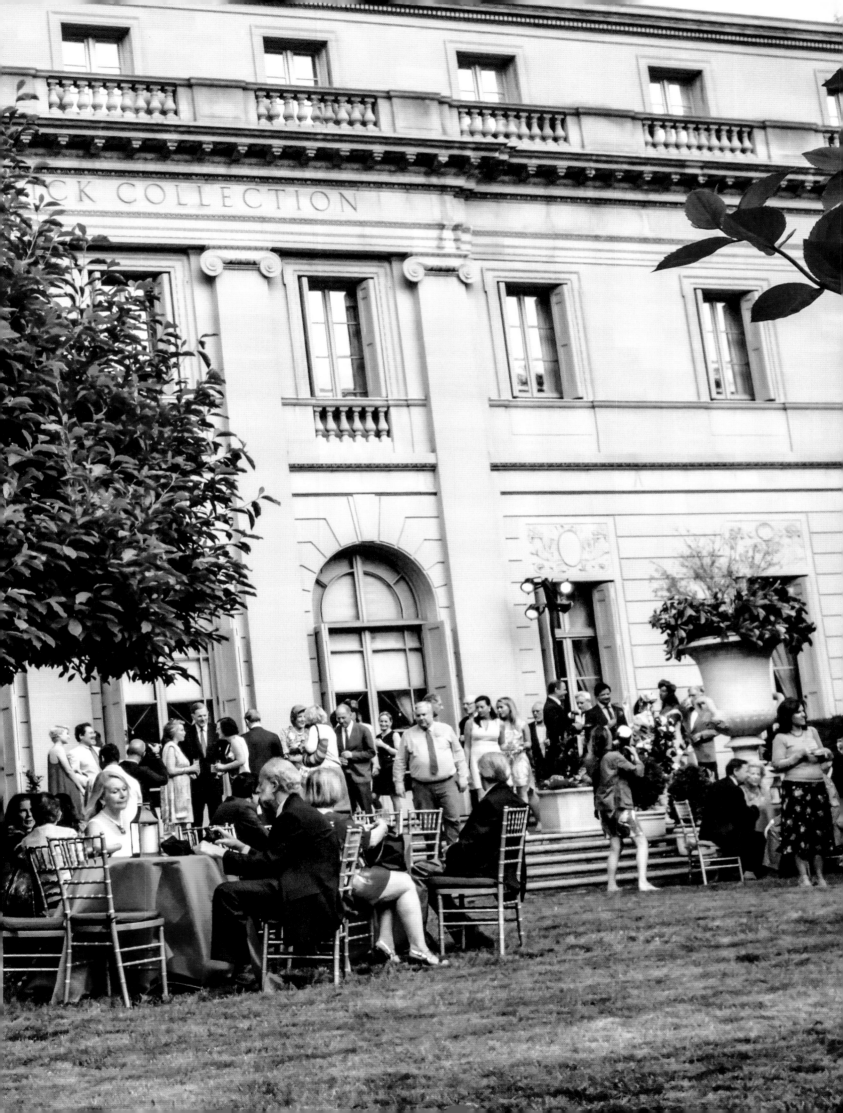

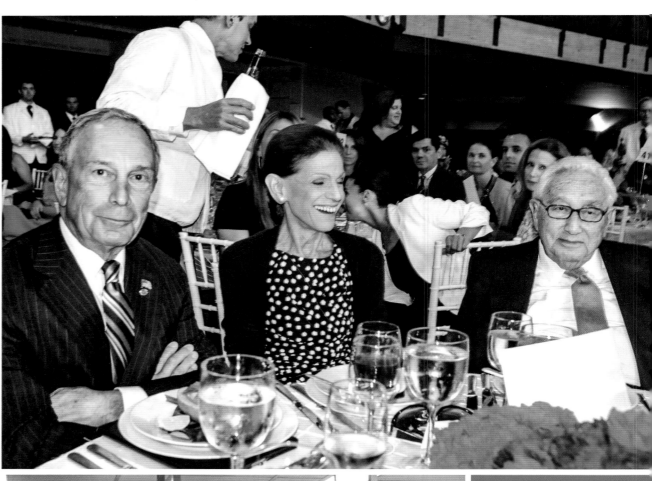

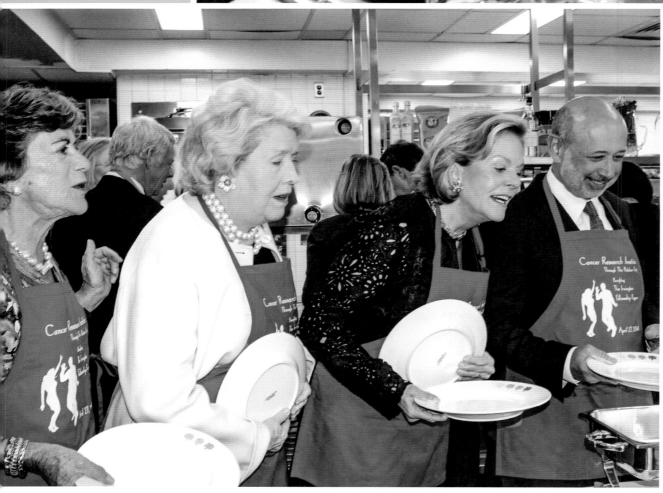

PRECEDING SPREAD The Frick Collection's annual Spring Garden Party, June 2015.

OPPOSITE, ABOVE Former New York City mayor Michael Bloomberg, Annette de la Renta, and Henry Kissinger at the 2012 Couture Council Awards Luncheon to benefit the Museum at the Fashion Institute of Technology.

OPPOSITE, BELOW Guests at the annual Through the Kitchen benefit for the Cancer Research Institute at the Four Seasons restaurant, 2014.

RIGHT Marian Sulzberger Heiskell at the Summer Solstice Sunset Soirée to benefit the Untermyer Gardens Conservancy in Yonkers, 2013.

BELOW Guests at the Spectator Luncheon at the annual Fitch's Corner Horse Trials in Millbrook, New York, 2009.

FOLLOWING SPREAD Actress Zoe Saldana in a feathered gown by Dolce & Gabbana at the 2016 Met Gala.

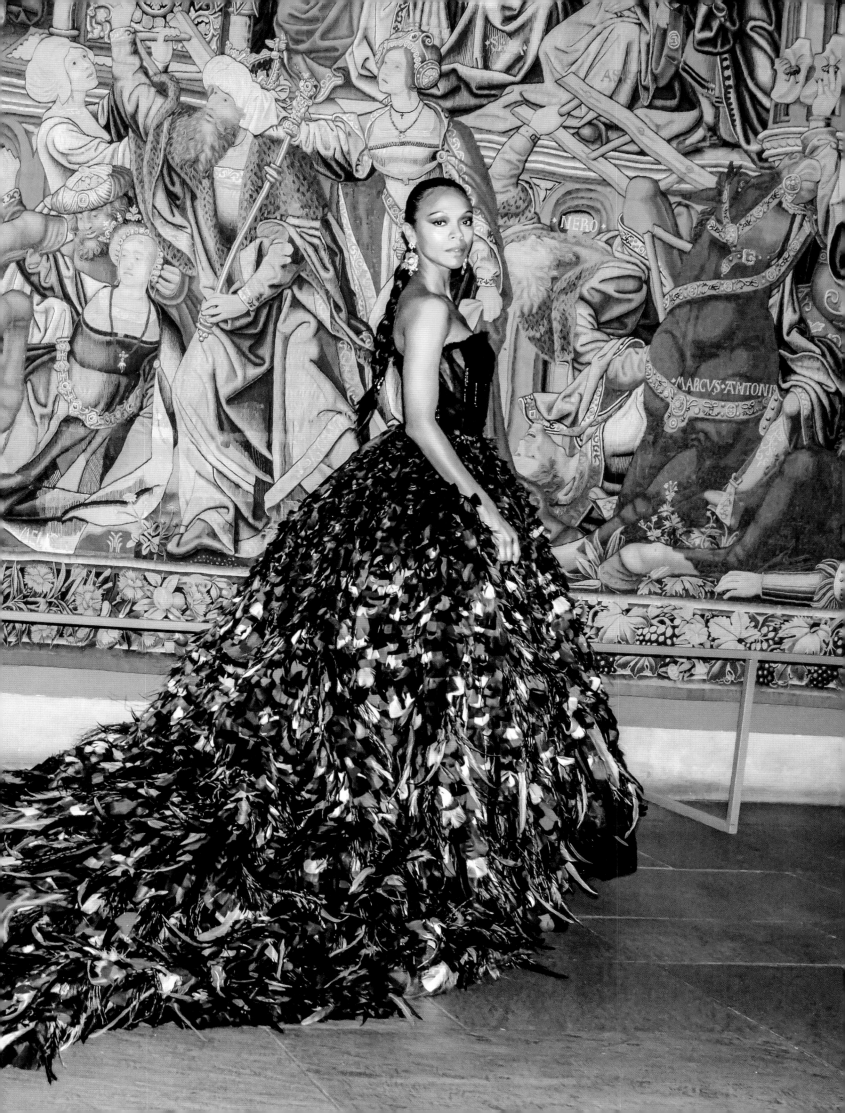

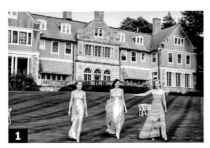
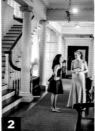

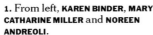

EVENING HOURS

Bill Cunningham

Augustly

How they shore up great houses in Bristol and Newport, R.I.

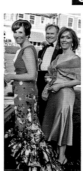

Aug. 16: Blithewold, a mansion, gardens and arboretum on Narragansett Bay in Bristol, R.I., celebrated its centennial. The 33-acre property was left by Marjorie Lyons to the public upon her death in 1976. Among the highlights are a bamboo grove and a giant sequoia tree, possibly the tallest east of the Rockies.

1. From left, **KAREN BINDER, MARY CATHARINE MILLER** and **NOREEN ANDREOLI**.
2. The entrance hall.
3. **MARJORIE SHAW JEFFRIES**.
4. **PETER J. RABBIT**.
5. **LESLIE BROWNE**.
6. A garden.
7. **ELLEN PLUNKETT**, left, **LAUREN McCARTHY** and **LAZ PUJOL**.
8. **JACQUELINE SAVOIE**, left, and **REENIE BARROW**, right.
9. **HEATHER SAVOIE**, left, and **CHERYL ANDREOZZI**.
10. **JOAN ABRAMS**.
11. **MIRIAM BASSI**.

Aug. 16: Dorrance (Dodo) Hamilton's birthday with 200 friends at the N... Mrs. Hamilton, a Campbell Soup ... thropist; her gifts include a $25 mi... ferson University.

12. **DODO HAMILTON** and some grandchildren.
13. **ANNE HAMILTON**, Mrs. Hamilton and **MATT HAMILTON JR.**
14. An ice sculpture of a dodo bird.
15. **ALA ISHAM** and **RALPH ISHAM**.
16. **VICTORIA MELE** and **NICHOLAS MELE**, her son.
17. **MARGARET DUPREY** and **GEORGE (FROLIC) WEYMOUTH**.
18. **JESSICA KENNEDY**, left, **HILARY COPP** and **CRAWFORD HAMILTON**.
19. From left, **HELEN WINSLOW, NOREEN DREXEL** and **RUTH HALE BUCHANAN**.

Aug. 15: The Preservation Society of Newport County held its annual benefit at the Breakers, the Vanderbilt summer mansion. The evening for 600 guests, called the Tiffany Ball, featured a raffle of Tiffany's trademark blue boxes, contents unknown.

20. Dancing in the great hall to the music of the Alex Donner Orchestra.
21. The reception.
22. **CHARLOTTE HAMILTON** and a partner.
23. From left, **EADDY KIERNAN, LACY KIERNAN** and **JESSICA HAMILTON**.
24. **ANNE ROBERTS** and **EUGENE B. ROBERTS JR.**
25. **ELIZABETH PRINCE DE RAMEL**, left, and **FERNANDA KELLOGG**.
26. **RUTH HALE BUCHANAN** and **HAROLD SANDS**.
27. **PAUL SZAPARY** and **DIANA SYLVARIA**.
28, 30, 32, 34. The Breakers.
29. From left, **MEREDITH EAGAN, JACKIE CONESE** and **KENDALL EAGAN**.
31. **MARK HULL** and **ISABELLE LIRAKIS**.
33. **ELIZABETH AVERY** and a dancing partner.
35. **BRANDON AGLIO**.
36. **TOPSY TAYLOR** and **JOHN PEIXINHO**.
37. **MARY ELLEN COLLINS** and **ROY COLLINS**.
38. **MINNIE** and **JAMES J. COLEMAN JR.**
39. **PETER B. ENGLEHART** of Tiffany presenting **TRUDY COXE** with a raffle prize.
40. From left, **LESLIE BALLARD HULL, MARY VAN PELT** and **GLADYS V. SZAPARY**.
41. **NICK** and **JACKIE DREXEL**.
42. From left, **RODERICK O'HANLEY**, Ms. Roberts and **JENNIFER BOOTH**.
43. **ROSEMARY PONZO**.
44. **NUALA PELL**, left, and **DALLAS PELL**.
45. **LORI TIERNAN**.
46. **CHARLOTTE HAMILTON**.

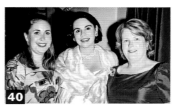

brated her 80th
Country Club.
is a philan-
Thomas Jef-

35

46

"Well, I'm just interested in people who look great. My god, it could be the cleaning lady!"

—BILL CUNNINGHAM

4

Think Pink
A STATE OF MIND

BEFORE THE PEACOCK Revolution that came out of London in the 1960s brought pink clothing into the mainstream regardless of the sex of the wearer, it had traditionally been a lady's color. Girls are swathed in pale pink as babies, sent to school in cotton-candy-pink hoodies, and attend their first high school dances in shocking pink dresses, the latter thanks to Madonna aping Marilyn Monroe in *Gentlemen Prefer Blondes* (1953). And while the fashion industry often attempts to present pink as a year-round color through cashmere, wool, and velvet, it remains a popular color for spring and summer. Paired with lime green, it serves as a dog whistle of the WASP world; paired with black, it suggests a throwback to the rock-and-roll era. Regardless, pink endures as it flatters most complexions and is simply pretty, no matter what shade or whether it is deployed as a solid or a print.

Given his past career as a milliner, Bill was naturally attracted to the color pink for all of its pleasing properties. However, the *New York Times* was one of the last newspapers to adopt color photography, hence its still-in-use nickname, the Gray Lady. The first color photograph appeared on the front page in the fall of 1997, but overall, color photographs were rarely published. In an article about the paper's transition to color, Tom Bodkin, the *Times* design director, recalled, "Our original 43rd Street printing press was too small to retrofit color presses." In time, additional printing facilities in Edison, New Jersey, and College Point, Queens, gave the photo editors the ability to use color more liberally, beginning with the Sunday edition and eventually throughout the daily paper.

Bill's first color photos were limited to his "On the Street" features, appearing only sporadically in the late 1990s. The complexities of his "Evening Hours" pages, with their prolific number of images, were daunting to the art department, especially given his frequent urges to substitute photos at the last minute. Advances in production technology, along with Bill's transition to digital photography in 2010, opened the floodgates of color for Bill. He took to this new aspect of photojournalism with wonder and enthusiasm, composing his ever-growing layouts with boundless energy—bringing to mind the painterly passion of Picasso.

Bill's talent for composition and fondness for considered juxtapositions were showcased especially well through the use of new technology, even though he himself resisted using such tools. He did not use a mobile phone or a computer, but still found his way in the emerging media ecosystem, not only visually but also with his charmingly instructive voiceovers that would accompany the online slideshows of the week's "On the Street" page. It's the fully composed pages, though, that remain as his finest work, featuring dramatic collages of color and form, whether highlighting single colors or rainbow motifs, or employing a complete lack of color in stunningly graphic black-and-white layouts. Separated from the vagaries of fashion and society, these pieces exist on their own as true works of art. ∎

OPPOSITE *An intricately folded Zac Posen ballgown of blush pink duchess satin, worn by model Karen Elson, catches the gaze of fashion icon Grace Coddington at the 2014 Met Gala.*

FOLLOWING SPREAD *Australian fashion writer Sarah Kelly creating a sensation outside of the Oscar de la Renta show during New York Fashion Week, 2015.*

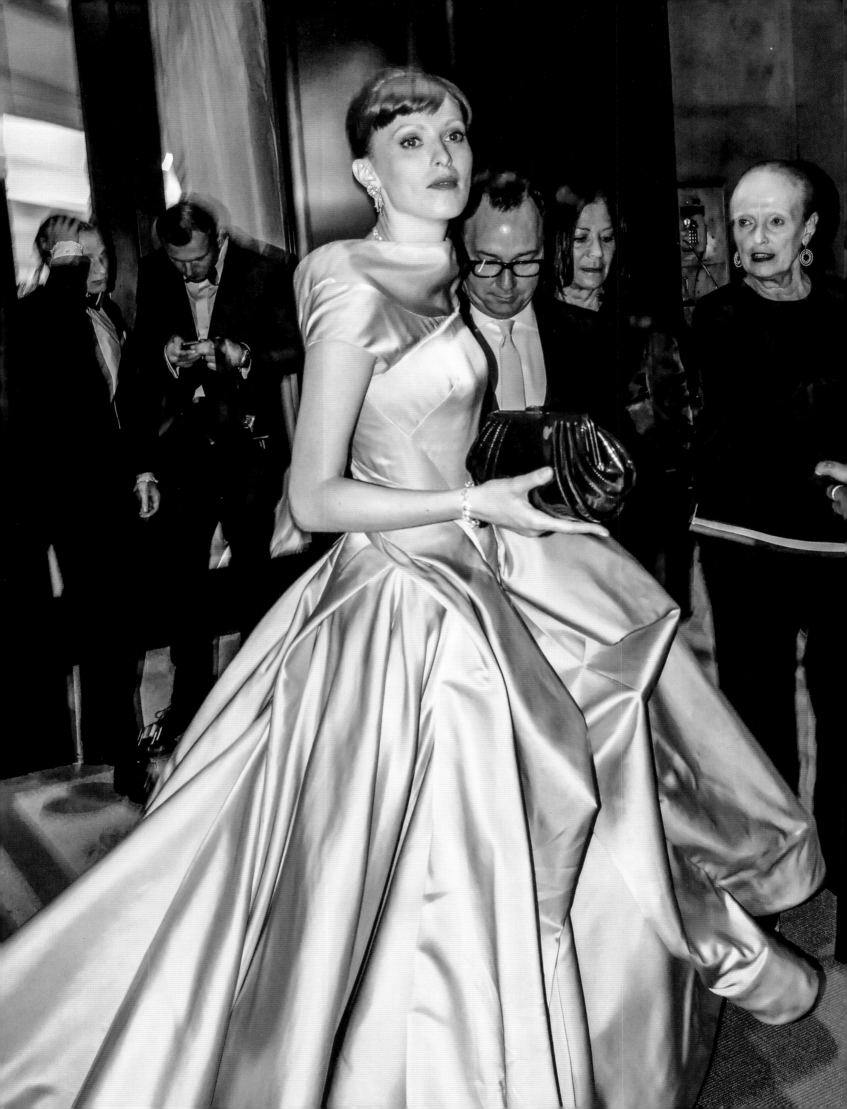

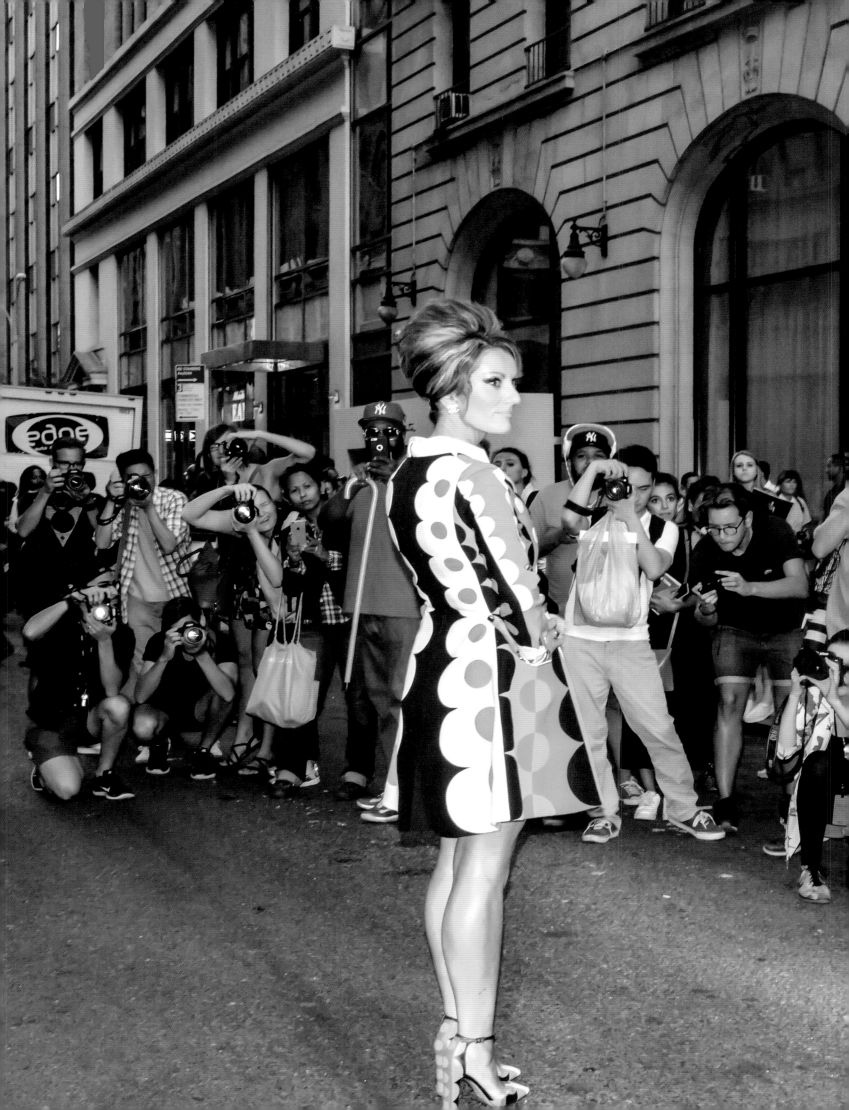

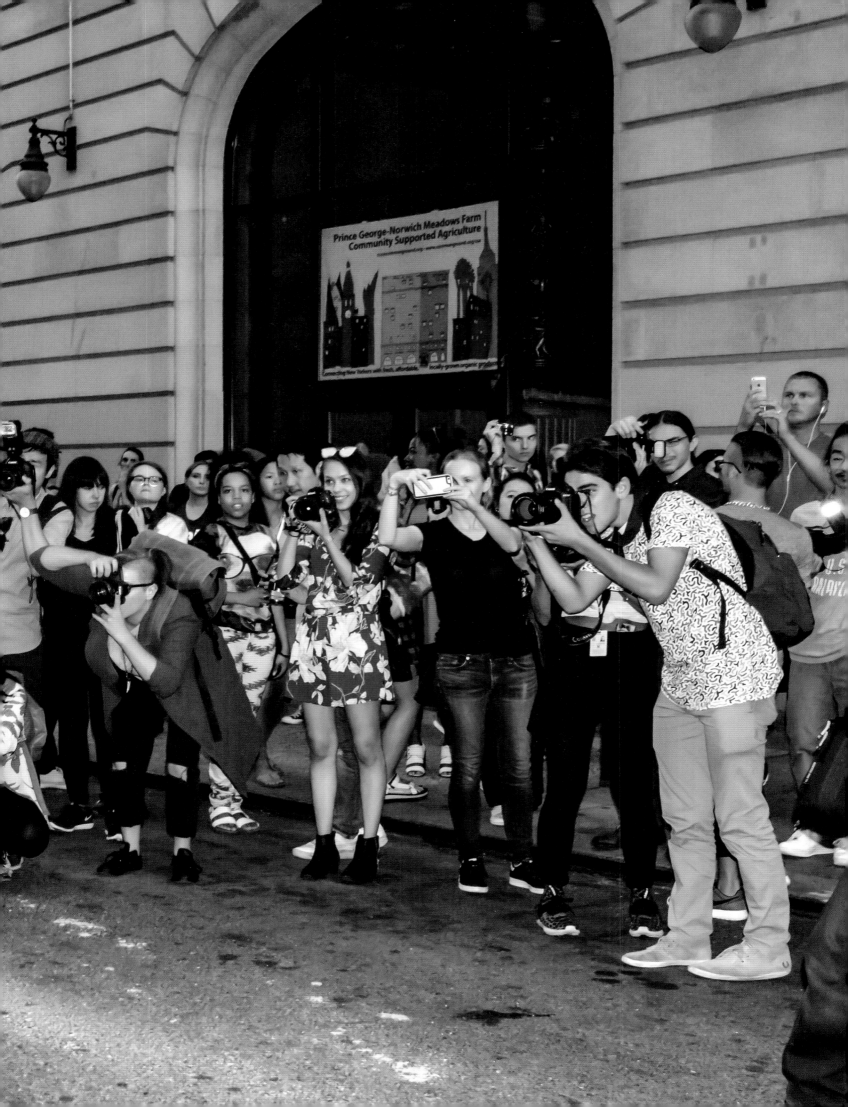

LEFT TO RIGHT Clouds of pink tulle and pretty prints making an entrance. | Jean Shafiroff in a pleated pink babydoll gown at the 2013 Wildlife Conservation Society Gala. | Model Elizabeth Hurley arriving at the 2014 Hot Pink Party to benefit the Breast Cancer Research Foundation at the Waldorf Astoria hotel.

FOLLOWING SPREAD Participants in the annual New York City Pride March, 2012.

"Today's full skirts rustle over the dance floor beneath laid-back tank tops and sweaters."

—BILL CUNNINGHAM

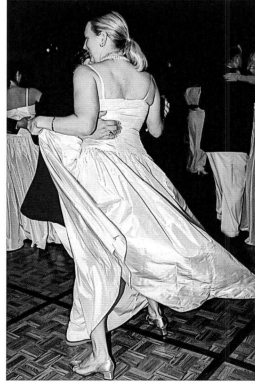

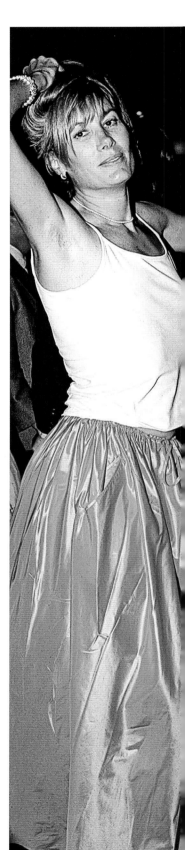

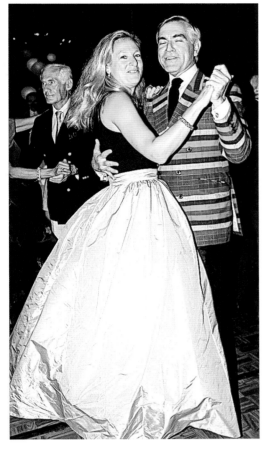

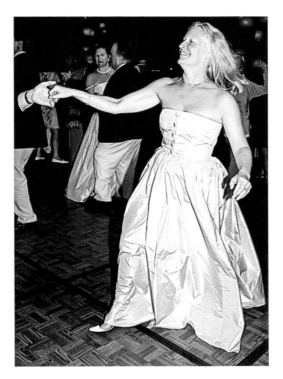

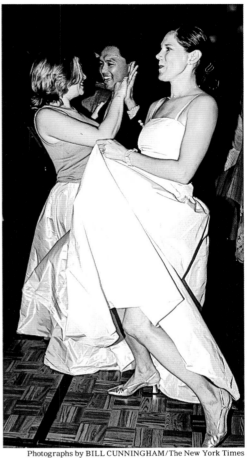

ON THE DANCE FLOOR

Vienna Hop

Photographs by BILL CUNNINGHAM/The New York Times

The taffeta waltz skirt is back, without the Johann Strauss formality, a casual look the designer Claire McCardell pioneered in the 40's. Today's full skirts rustle over the dance floor beneath laid-back tank tops and sweaters. Designs by Steven Stolman of Southampton, whose $325 skirts are built on a waistband, were the rage at the town's recent hospital benefit. Other designers use drawstring waists (center left), a bit risky for exuberant dancing.

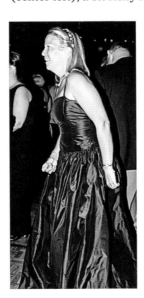

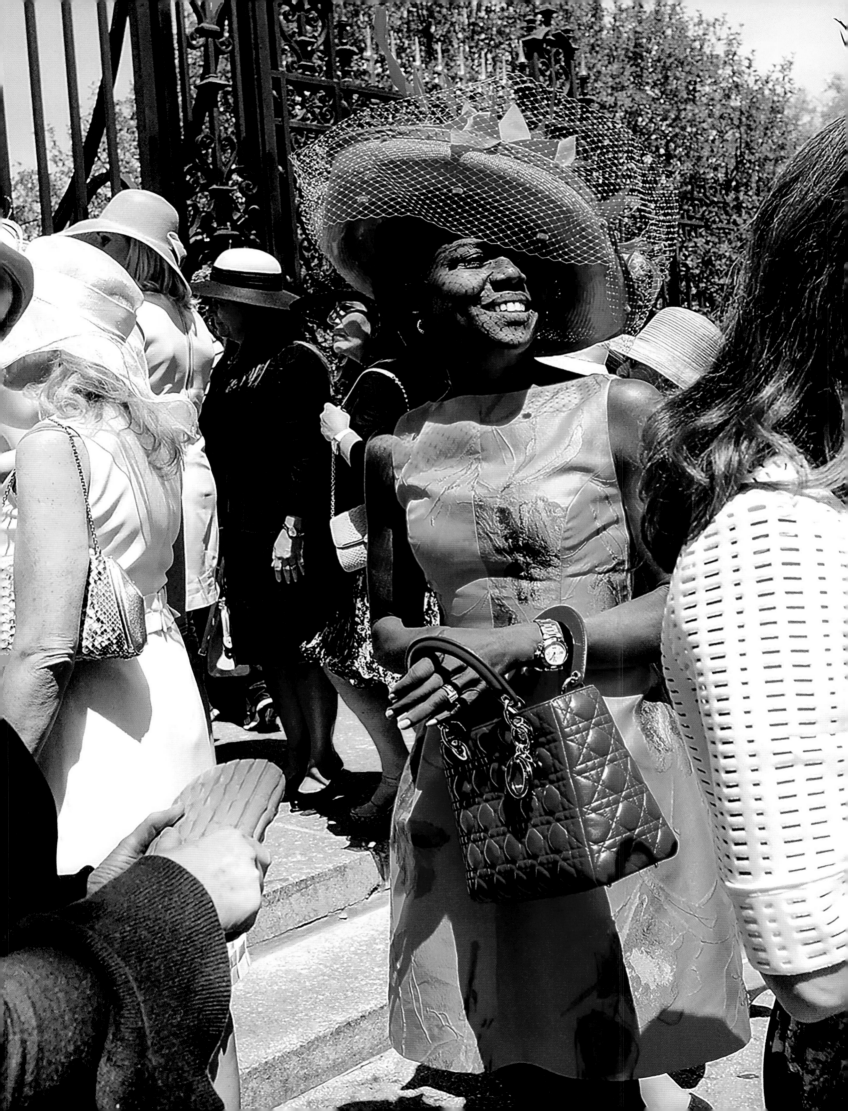

Does Anyone Still Wear a Hat?

CENTRAL PARK

HATS, AND GLOVES for that matter, were de rigueur for well-dressed ladies until the seismic cultural changes of the 1960s relegated them to thrift shops and backs of closets. The bouffant hairdo, as popularized by First Lady Jacqueline Kennedy, also played a part in the demise of the everyday hat. Spring and summer hats remained on the market in a small way, thanks to the traditions of Easter, the hippie-era style of floppy hats and granny glasses, and the increasing awareness of the effects of the sun on skin. The disco era and the broad-shouldered 1980s briefly revived the cocktail hat, usually trimmed with a pouf of netting or a *petite* veil, but it remained a costumey look, best worn by such performers as Grace Jones and Joan Collins.

OPPOSITE *Deborah Roberts (Mrs. Al Roker) in chic rose-printed taffeta with a matching wide-brimmed hat.*

It was the marriage of Lady Diana Spencer to Prince Charles in 1981 that re-popularized the day hat for weddings and sporting events such as polo matches and horse racing, at least in America (although hats have never disappeared from the Kentucky Derby.) In Europe, especially the United Kingdom, the day hat never went out of fashion because the Queen continued to wear one for all informal public appearances.

But for the many well-heeled patrons of the Women's Committee of New York's Central Park Conservancy, an elegant daytime hat is a wardrobe essential at its annual signature event. Every May, the committee presents the Frederick Law Olmsted Awards Luncheon, affectionately known as "the hat luncheon." In a soaring tent set up in the Conservatory Garden at Fifth Avenue and 105th Street, more than twelve hundred exquisitely hatted women (and a few men) gather annually to raise millions of dollars for the upkeep of the park.

As a former milliner, Bill looked forward to this extravaganza of hats like a child looking forward to a trip to Disney World. The opportunity to document actual women, not models, sporting the latest in spring fashions accessorized by magnificent hats made him positively giddy. Amplifying his joy was the explosion of flowers in the gardens. For Bill, it was a perfect storm of beauty, and always resulted in some of his most successful pages.

Later on in the summer, Bill would travel to other hat-centric events such as the Bridgehampton polo matches, the races at Saratoga Springs, and the Hampton Classic Horse Show. But nothing could compare to the hat luncheon. It remains the gold standard of gatherings in New York where *everybody* still wears a hat. ∎

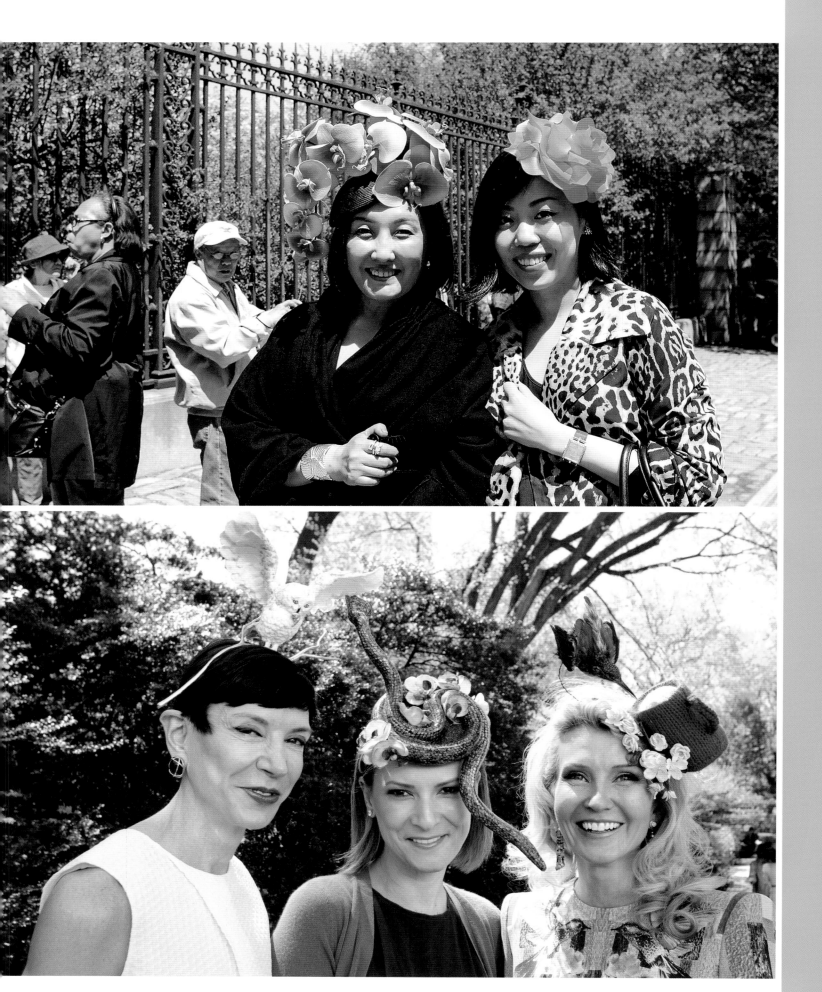

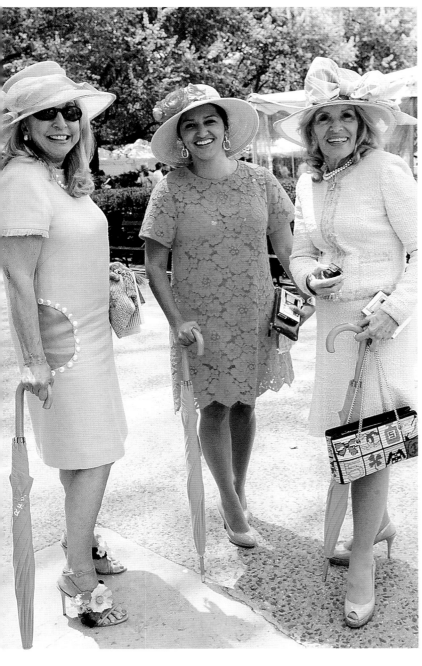

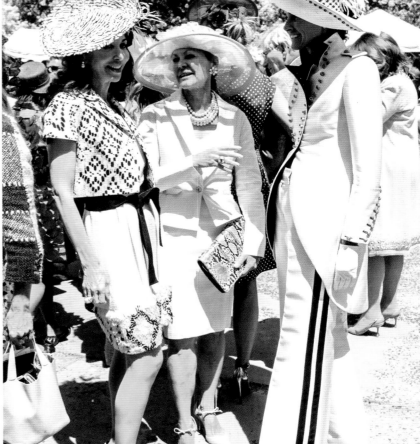

OPPOSITE, ABOVE Orchids, roses, and a touch of leopard on Yan Sun and Nan Song at the Frederick Law Olmsted Awards Luncheon to benefit the Women's Committee of the Central Park Conservancy.

OPPOSITE, BELOW Amy Fine Collins, Lizzie Tisch, and Kathy Prounis all sport fascinators decorated with wildlife motifs at the Central Park "hat luncheon," 2013.

ABOVE Eleanora Kennedy, Anna Kennedy, and Annette Urso-Rickel with orange umbrellas from Wathne, 2014.

RIGHT Fe Fendi, Muffie Potter Aston, and Somers Farkas in black and white, an elegant 2014 statement reminiscent of Cecil Beaton's designs for the 1964 film *My Fair Lady*.

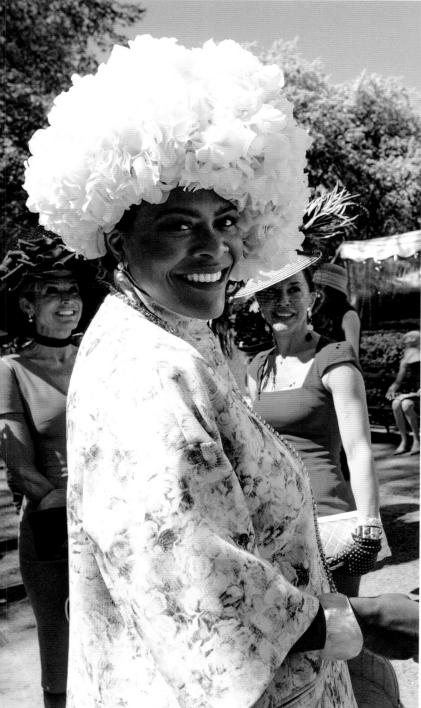

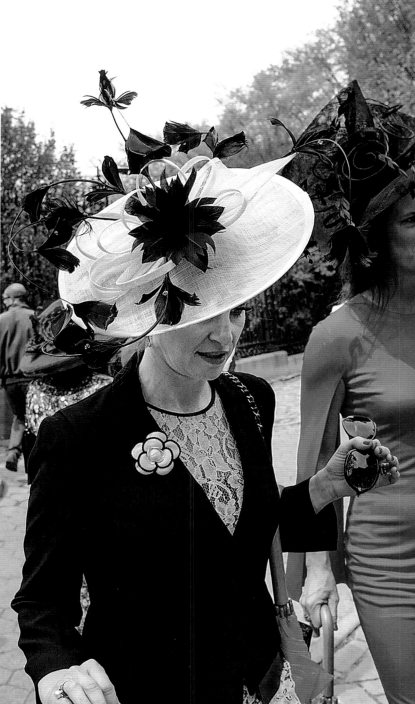

LEFT TO RIGHT Lydia Carlston wears an exquisite turban of fresh hydrangea, Central Park hat luncheon, 2013. | A saucer of white straw is trimmed with black feathers. | Carole McDermott's whimsical hat features a miniature replica of the Central Park Dairy atop her head.

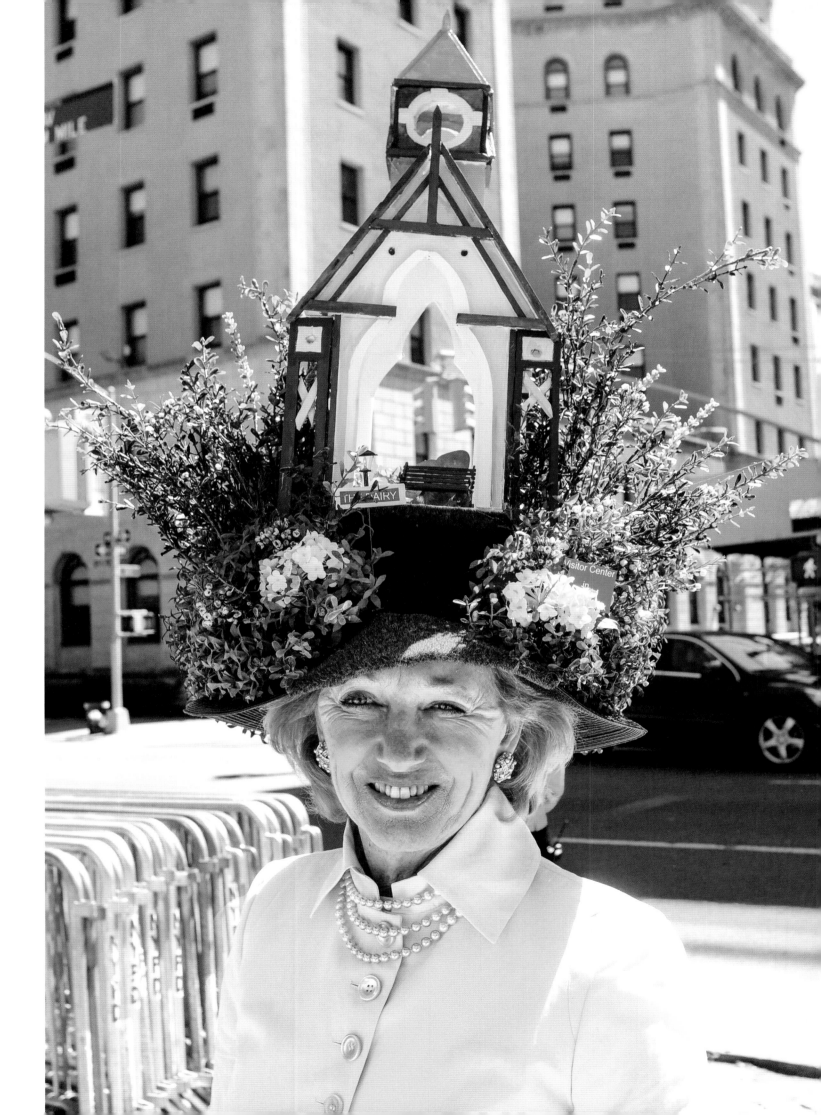

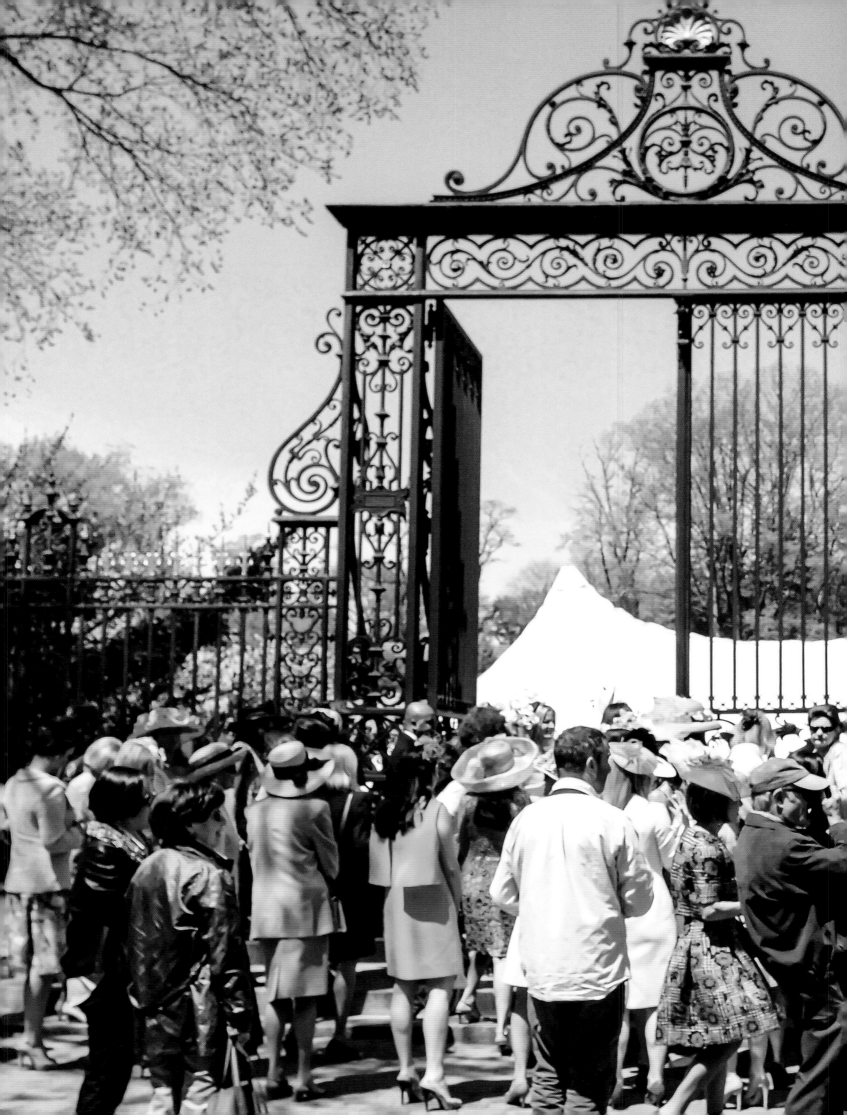

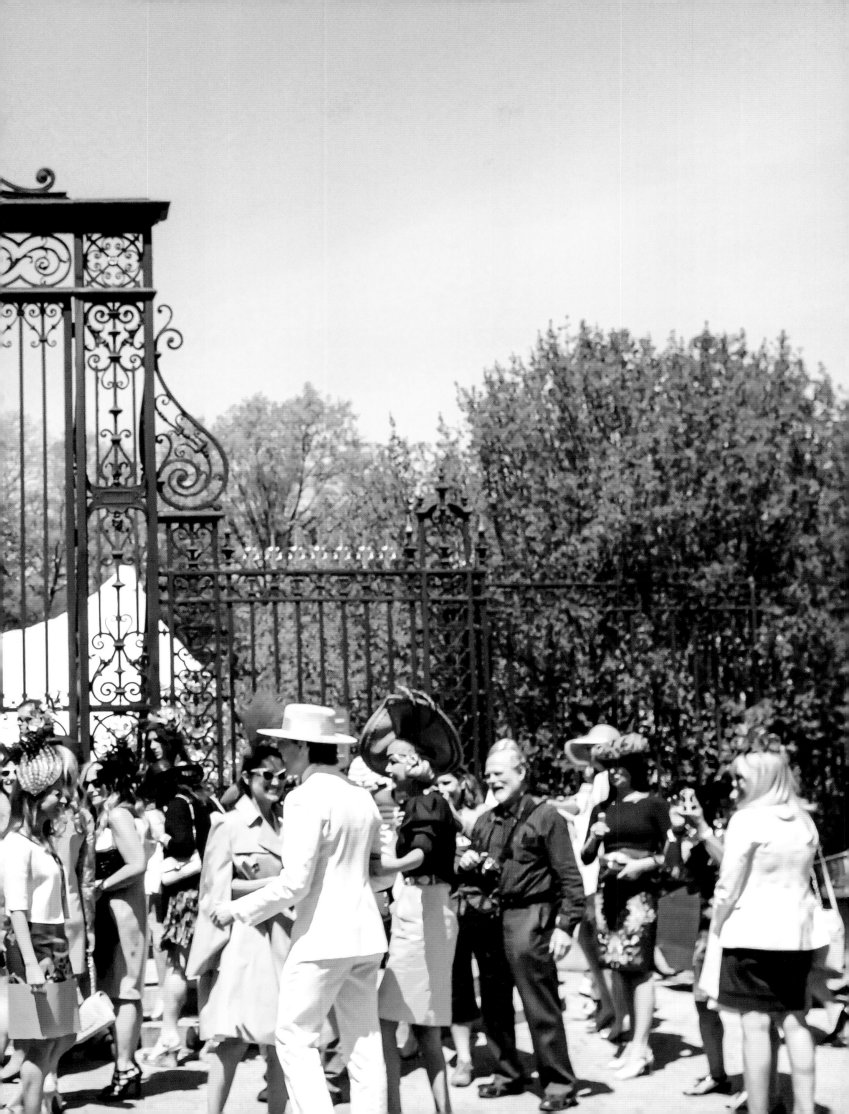

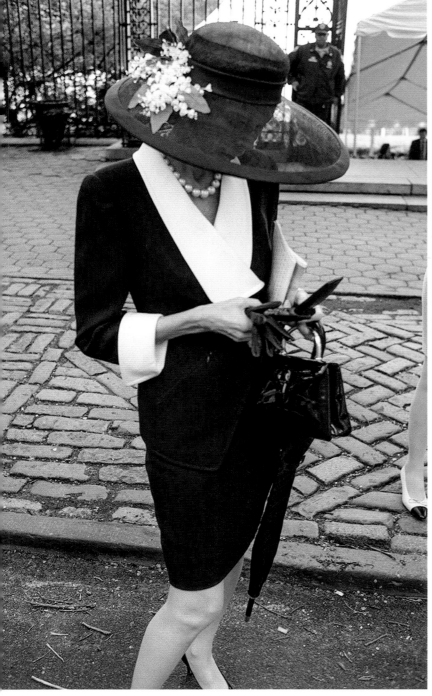

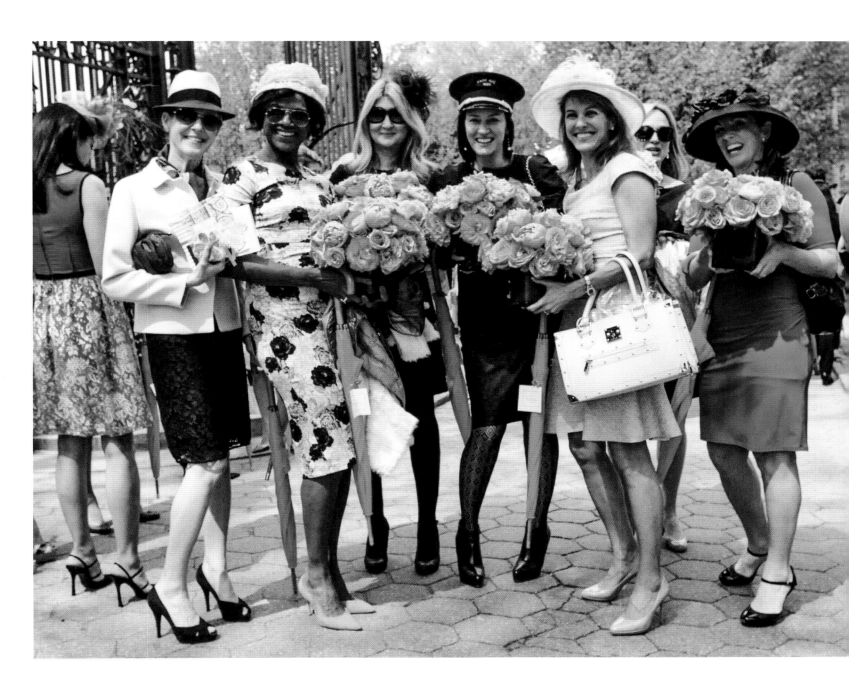

PRECEDING SPREAD The stylish scrum assembled in front of Central Park's Vanderbilt Gate

LEFT TO RIGHT Demure, mannerist perfection was always a favorite of Bill's. | John Kurdewan chats with Diana DiMenna in front of the Vanderbilt Gate. | A group of chic ladies departs the luncheon with a haul of centerpieces and umbrellas, 2014.

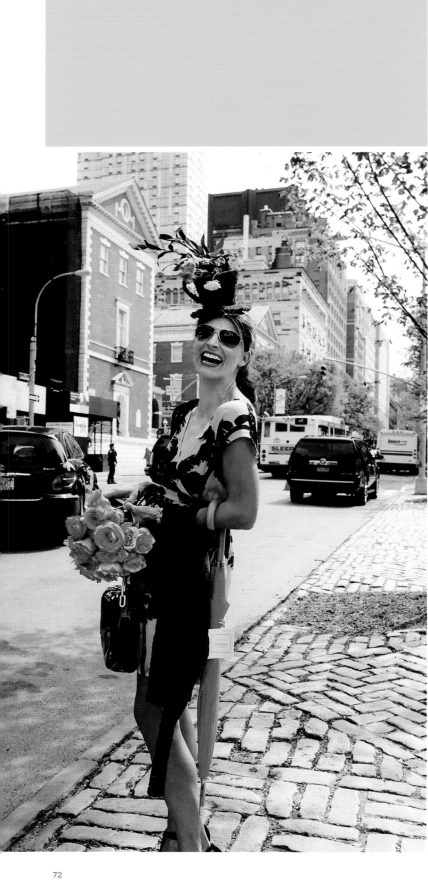

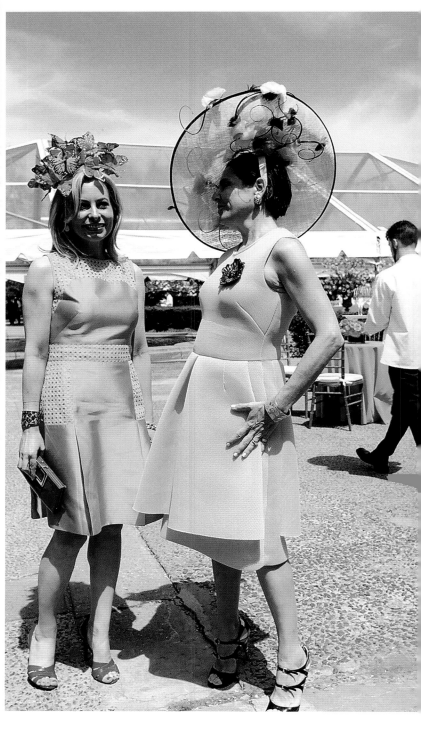

LEFT TO RIGHT A departing guest wears a teacup topper brimming with flowers. | Gillian Miniter in saffron silk topped by a swarm of butterflies, with Alexandra Lebenthal in a dramatically tilted straw saucer trimmed with delicate blossoms and tendrils. | Rambunctious hats, sky-high heels, and diminutive handbags were clearly the look of the day. | Amelia Ogunlesi's black straw fascinator features an underlay of gravity-defying lace.

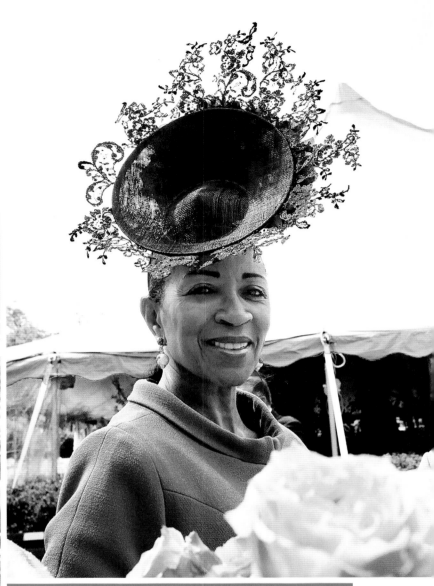

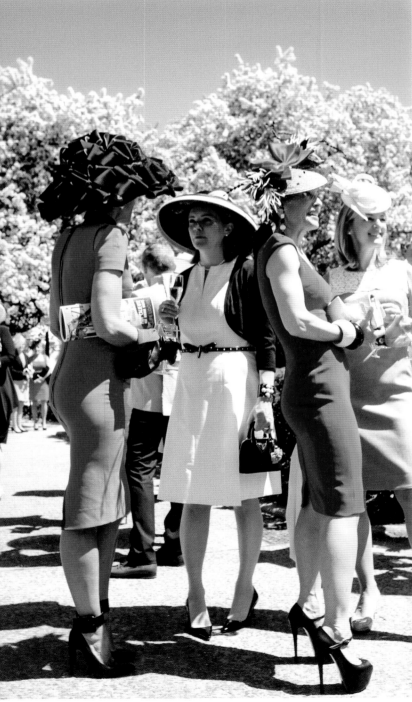

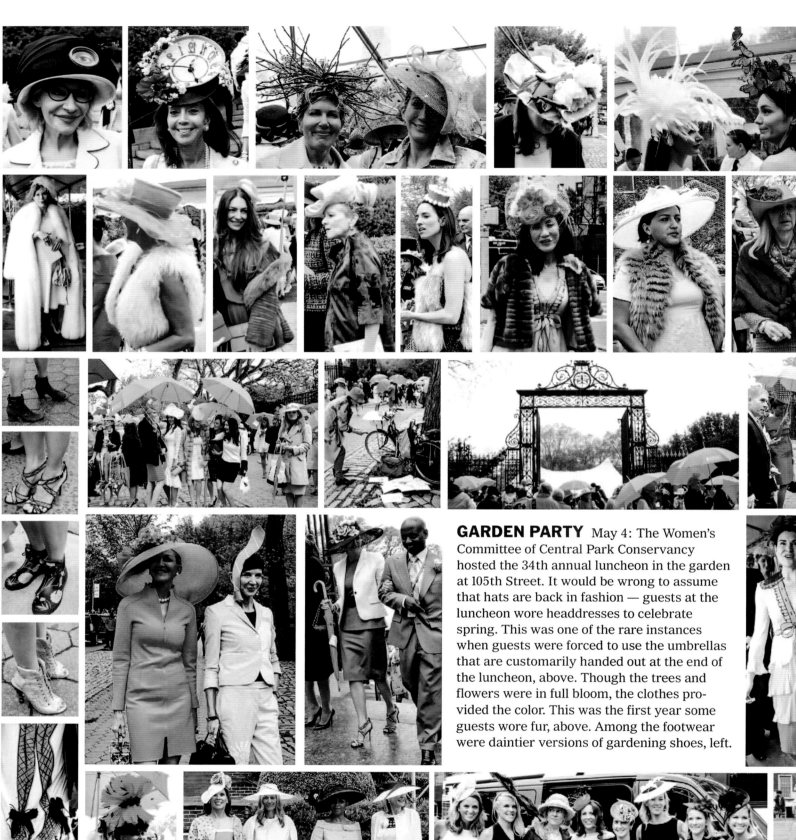

GARDEN PARTY May 4: The Women's Committee of Central Park Conservancy hosted the 34th annual luncheon in the garden at 105th Street. It would be wrong to assume that hats are back in fashion — guests at the luncheon wore headdresses to celebrate spring. This was one of the rare instances when guests were forced to use the umbrellas that are customarily handed out at the end of the luncheon, above. Though the trees and flowers were in full bloom, the clothes provided the color. This was the first year some guests wore fur, above. Among the footwear were daintier versions of gardening shoes, left.

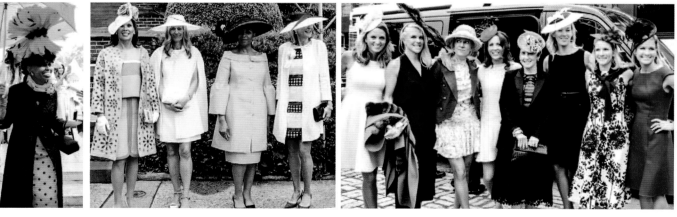

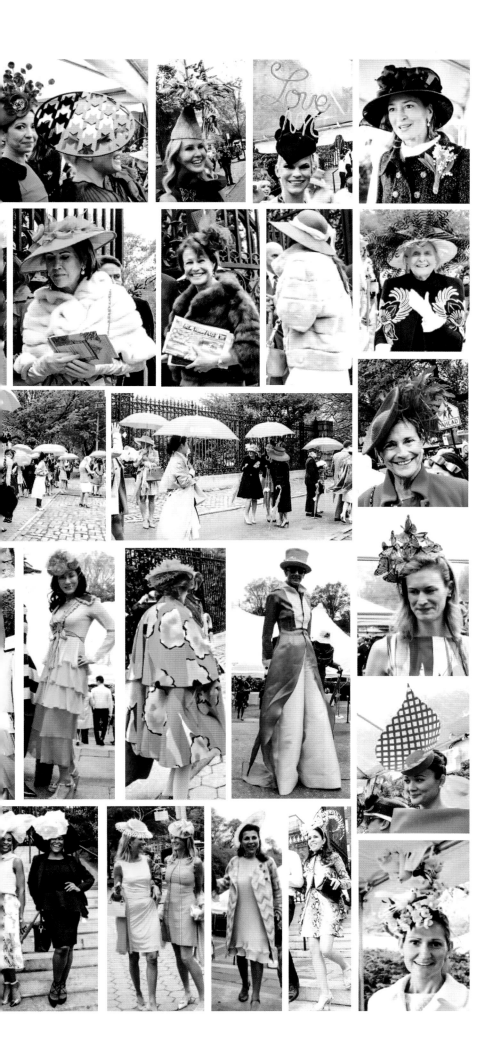

6

Florals
PETALS AND PATTERNS

FOR AS LONG AS humanity has had the ability to embellish cloth—whether through painting, printing, or embroidery—flowers have been a popular motif for decoration. There is a design and decor chestnut that states, "Two colors that exist in nature together always work." This could not be more true than when applied to florals. Almost any pretty color that might be on a petal paired with any leafy green looks fresh and lively. Women typically embrace the insouciant charm of floral prints as a tonic to the dark, neutral, heavily layered fashions of fall and winter. They suggest a lighthearted renewal and are generally thought of as being "happy" motifs.

Bill especially loved blooming flowers and clothes inspired by them, and if he had the opportunity to juxtapose a garment with actual flowers, all the better. From day to evening, informal clothes to gowns, Bill's eye would always gravitate to exceptional examples of floral fashion, celebrating nature in much the same way as artists have for time immemorial.

The major social events of spring and summer were especially ripe for Bill's love of horticulturally themed fashion, from hats bursting with blooms at the annual hat luncheon to benefit the Central Park Conservancy to the extravagant designer creations seen on guests at the grand Conservatory Ball to benefit the New York Botanical Garden. Add to this the Frick Collection's annual Spring Garden Party for Fellows and Young Fellows and the American Ballet Theatre's Spring Gala, and the opportunities for Bill and his camera to indulge in this beloved expression of fashion were seemingly endless. Luckily, throughout his five decades as a chronicler of society and dress, Bill never became bored with this subject matter. Year after year, he would appear, Zelig-like, at party after party, often covering several events on the same day or evening, and would return to the art department of the *Times* with his haul. To describe the pleasure he took in his work as "a kid in a candy store" would be an enormous understatement. His delight was infinite, as was his enthusiasm. Bill possessed a deep knowledge of the craft of millinery, dressmaking, textiles, and embroidery, along with the tenets of haute couture, especially *le flou*, as he would describe the weightless flow and movement of a properly constructed dress.

Bill was especially adept at observing evolving technology as it applied to apparel, and the execution of floral motifs was of special interest. He was able to instantly recognize embroidery techniques, and was a great admirer of the work of the French house Lesage, which is now part of Chanel through its subsidiary, Paraffection. Another French favorite was Houlès, known for its exquisite passementerie. The depiction of buds, blooms, and leaves using these time-honored materials and techniques always caught Bill's eye. But he was also fascinated with the emerging technologies of laser cutting and digital printing, as documented in his photography and musings. Regardless of whether the product was traditional or avant-garde, Bill consistently celebrated this significant aspect of fashion. ∎

OPPOSITE *Theater and film producer, and Bill intime, Diana DiMenna in a dress embroidered with a veritable garden of blooms at the New-York Historical Society, 2015.*

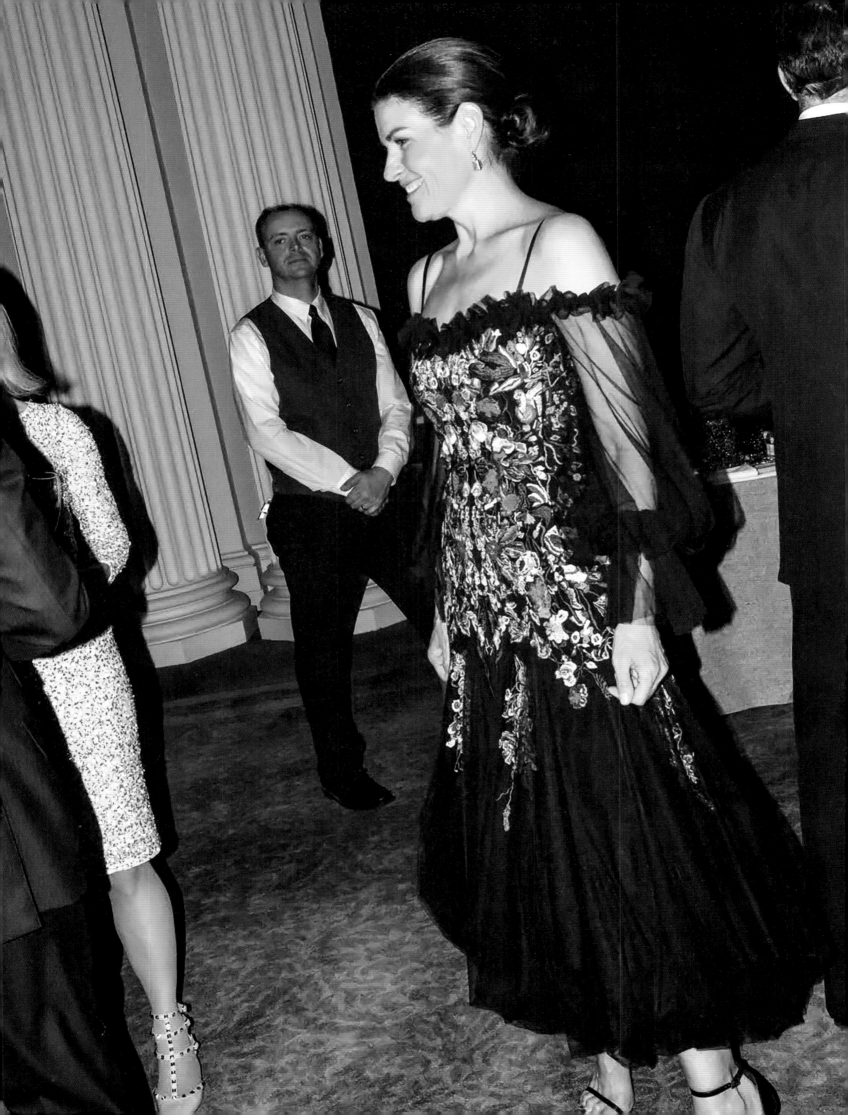

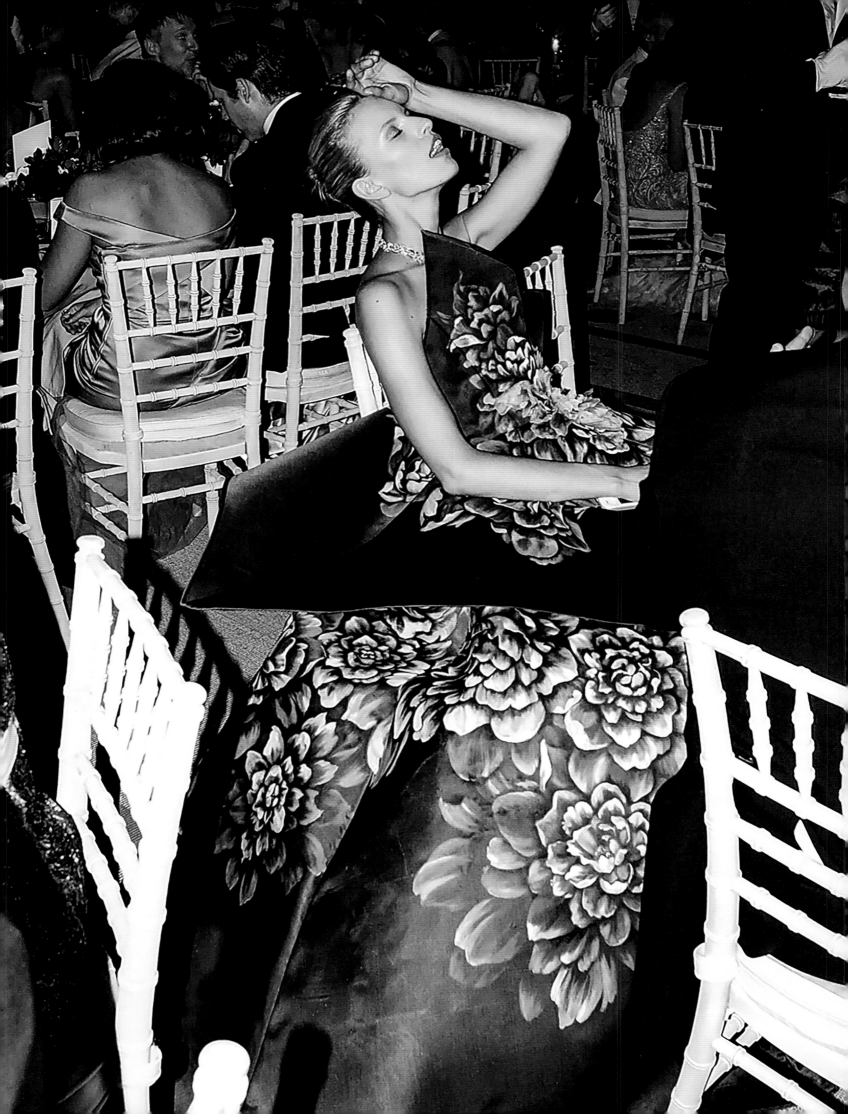

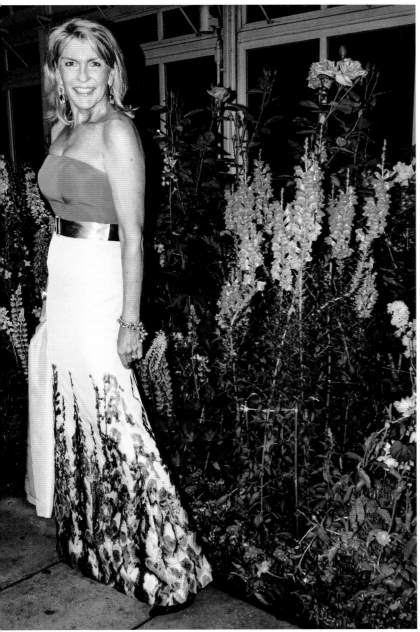

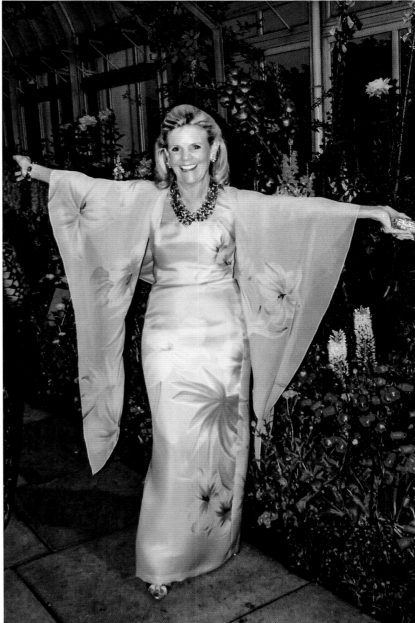

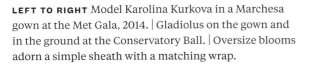

LEFT TO RIGHT Model Karolina Kurkova in a Marchesa gown at the Met Gala, 2014. | Gladiolus on the gown and in the ground at the Conservatory Ball. | Oversize blooms adorn a simple sheath with a matching wrap.

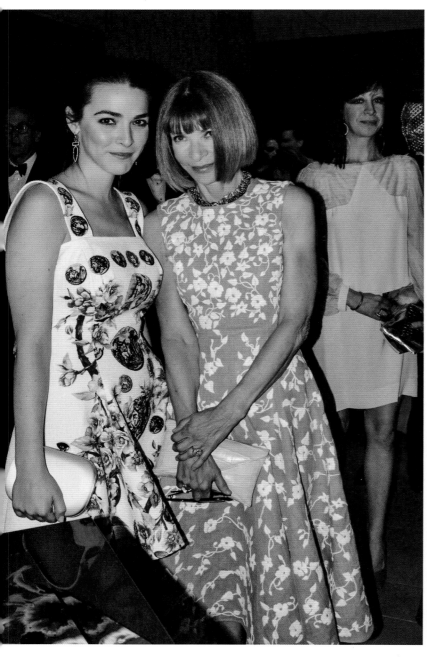

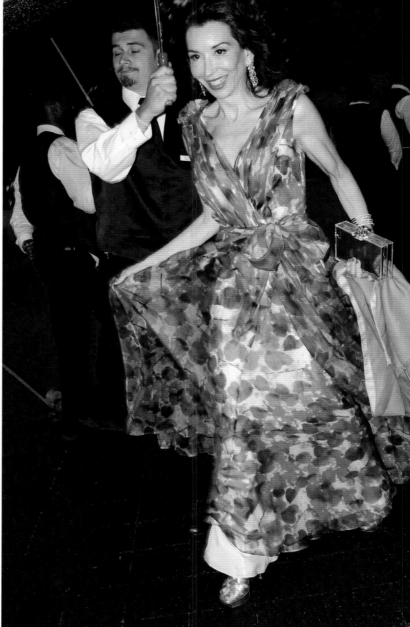

LEFT TO RIGHT Blooming branches on Bee Shaffer with her mother, Anna Wintour, in a more subdued floral dress at the CFDA (Council of Fashion Designers of America) Awards at Lincoln Center, 2014. | Veronica Hearst in a sheer, poppy-printed gown. | Color-coordinated to perfection: Gregory Long, Carolina Herrera, Gillian Miniter, Alexandra Lebenthal, and Deborah Royce at the Conservatory Ball to benefit the New York Botanical Garden, 2015.

FOLLOWING SPREAD Guests at the triennial Coaching Weekend in Newport emerge from the carriage house at The Breakers, 2015.

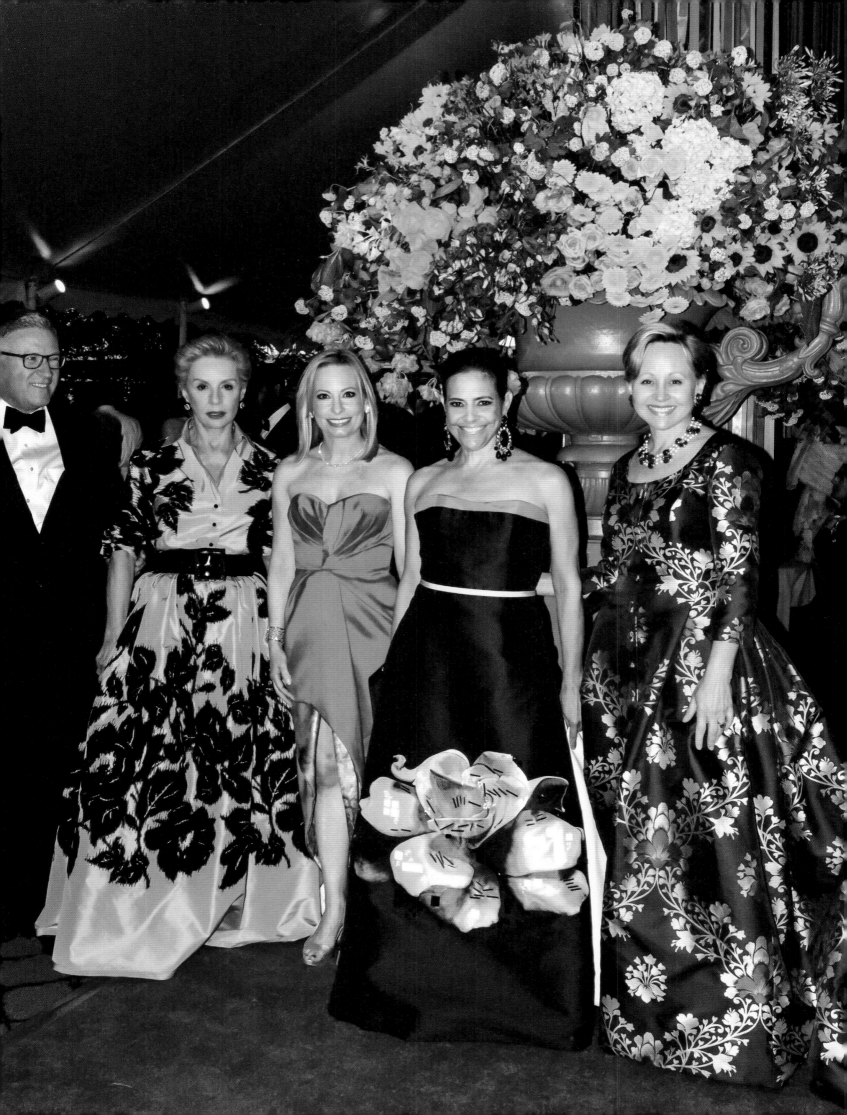

ABOVE The color of both the hat and suit are echoed by the tulips at the Central Park hat luncheon.

RIGHT A red-and-white abstract floral-print dress is perfectly accessorized by futuristic red-and-white sunglasses.

OPPOSITE, LEFT Mercedes Bass in a demure pintuck floral silk dress in Central Park.

OPPOSITE, RIGHT Jamee Gregory in a poppies-over-plaid gown at the Conservatory Ball, New York Botanical Garden, 2014.

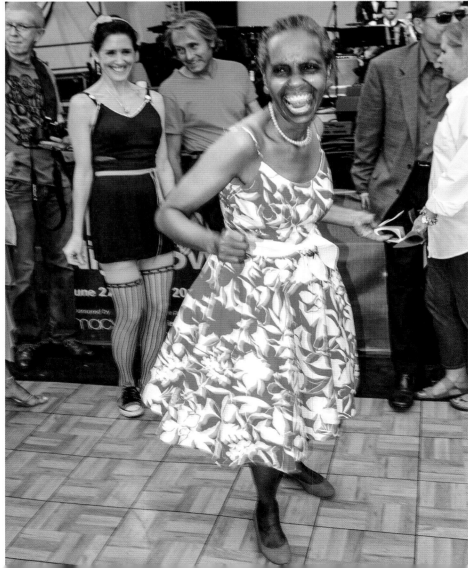

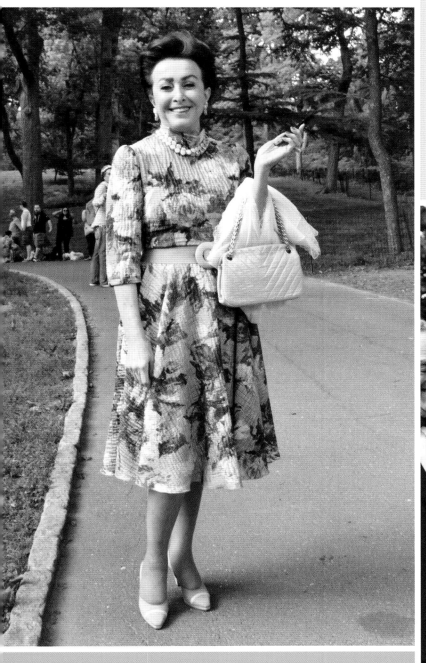

By the Sea

OUT EAST

THE GRAND estates of Southampton, built by fortunes made on Wall Street and the emerging industries of the early twentieth century, and surrounded by manicured privet hedges, captivated Bill from the moment he arrived in New York City as a young man. Indeed, women with family names such as Merrill, Murray, and Ford found their way into Bill's orbit throughout his entire life. When he had his own millinery business, he followed them out to Southampton in the summer and even opened a seasonal salon on Jobs Lane, the tony shopping street.

Once he became a bona fide member of the fashion and society press, he would travel to Southampton and its adjacent towns to cover the various summer galas and other events such as the polo matches and the Hampton Classic Horse Show. True to form, he would never accept an offer of private transportation for the ninety-mile journey, preferring to take the Long Island Rail Road and many times walking from the station to the party. In later years, he would sometimes hitch a ride from a passerby.

While consistently democratic and obsessively ethical in his coverage, one major Southampton event seemed to catch his fancy like no other: the annual Summer Party to benefit Southampton Hospital, now Stony Brook Southampton Hospital. Similar in scale to the Central Park hat luncheon, this tented dinner dance allowed Bill to survey the season's fashions with unmatched efficiency throughout his entire career. While men have consistently attended this event in the traditional Hamptons summer-gala uniform of blue blazer and white trousers with a mixed bag of open shirts and neckties, women have gone all out, sporting cocktail ensembles and gowns usually seen only at black-tie events. The juxtaposition of open fields and country roads with dramatic dresses proved irresistible to Bill year after year, along with a strong showing of the old guard families who have fascinated Bill from his earliest days

covering his beat. At the Southampton Hospital gala, Bill had the luxury of photographing a broad range of subjects, from lithe young women in weightless, flowing dresses to socialites in ballgowns and evening gloves, along with everything in between. He developed a special affection for a handful of attendees that he could count on seeing every year that he was there (in later years, he had to choose between the Southampton Hospital gala and a conflicting event in Newport, always a source of disappointment for certain Hamptons socialites). His "shot list" was as eccentric as he was, from the scions of a Broadway dynasty to the last holdouts of the Social Register to a charming couple who always arrived at the event in resplendent outfits but also by bicycle. And regardless of name or social stature, if there was a sensational dress among the thousand or so guests, Bill would find it and have a field day. ∎

OPPOSITE *At the 2014 "White Hot + Blue" benefit for the LongHouse Reserve in East Hampton, synchronized swimmers entertained the guests.*

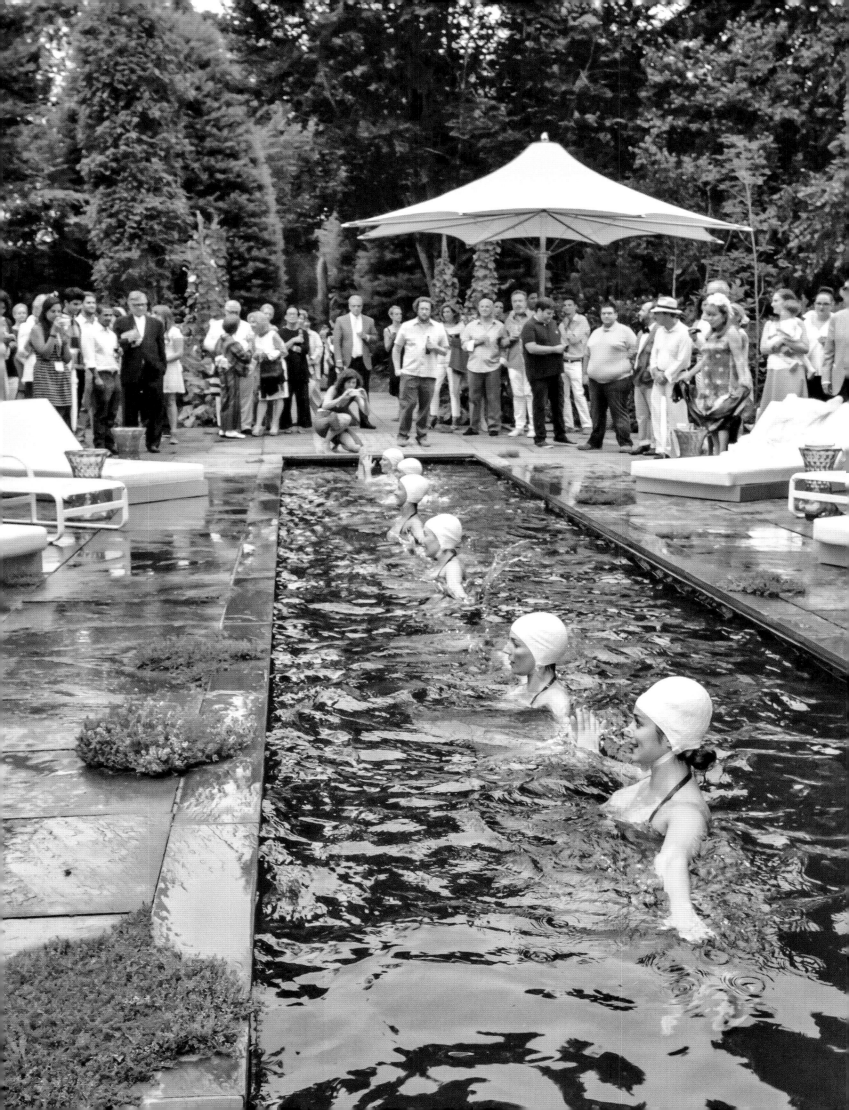

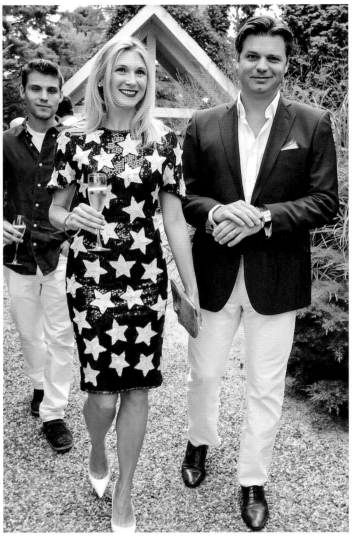

THIS PAGE, CLOCKWISE FROM TOP LEFT The classic Hamptons look of blue and white receives an extra dose of glamour via a star-spangled sequined dress. | Guests awaiting entry to the Watermill Center summer benefit. | All attendees at the Fire Island Dance Festival arrive by boardwalk, as cars are forbidden on the entire barrier island.

OPPOSITE Somers Farkas, always a standout in whatever she wears, at the Midsummer Party to benefit Southampton's Parrish Art Museum.

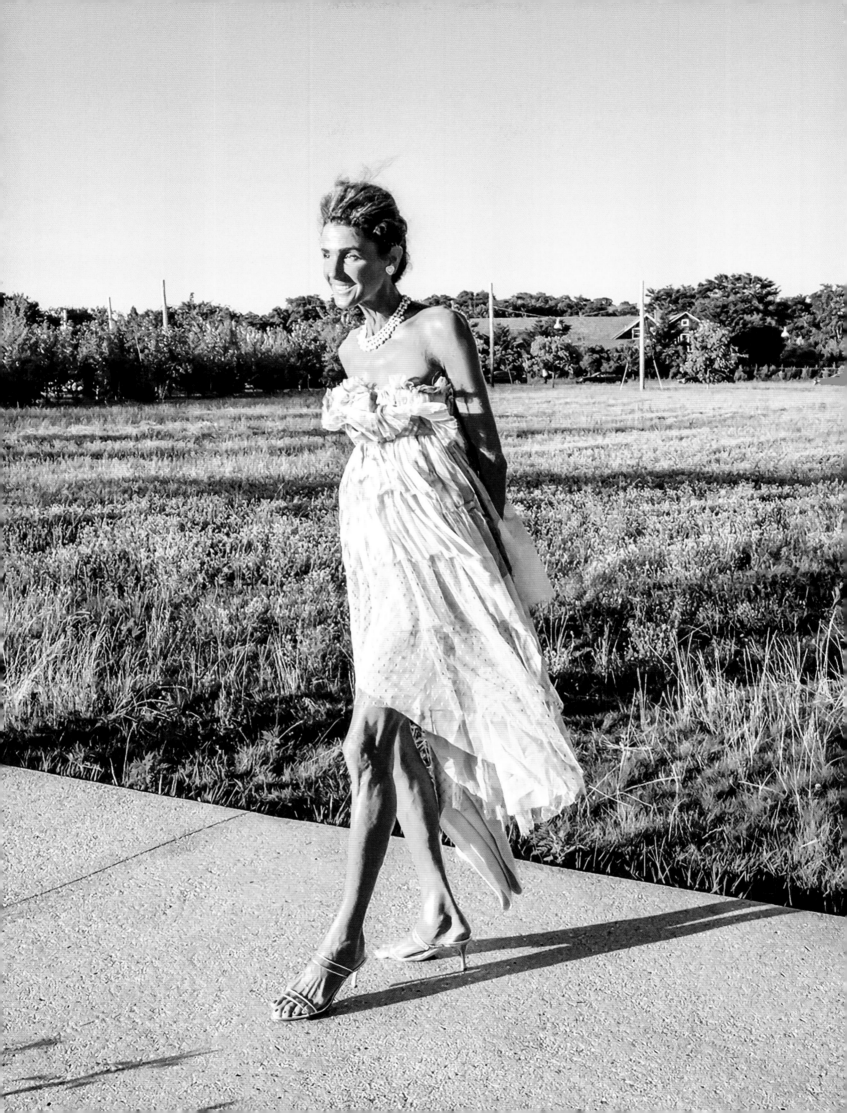

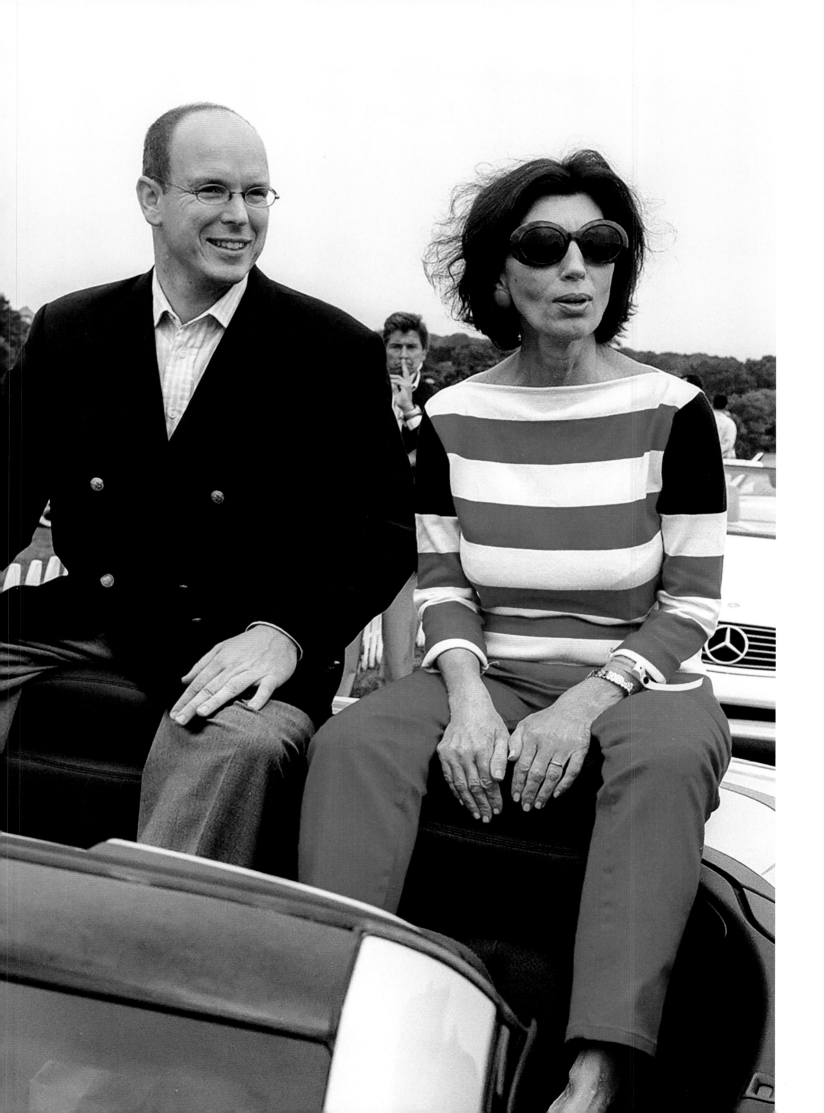

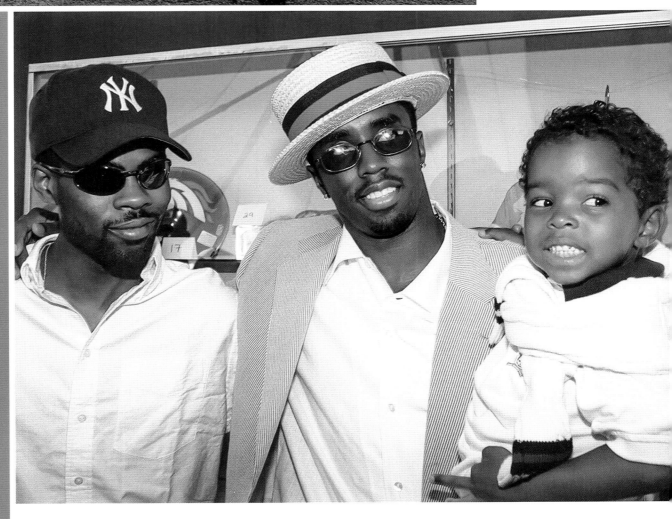

OPPOSITE Prince Albert II of Monaco and magazine editor and author Pamela Fiori at Bridgehampton Polo, 2001.

LEFT The sport of kings in action at Bridgehampton Polo.

BELOW Hip-hop icon Sean Combs, here with comedian Chris Rock and Combs's son Justin, hosted a benefit auction for Daddy's House at the Bridgehampton Polo Club, 1998.

1

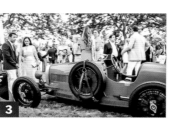

2

3

Fine Arts

27

Aug. 4: The Southampton Hospital held its annual benefit for more than 800 guests in a tent in the open fields adjacent to the hospital. A display of racecars fit the theme of the Grand Prix of Monaco.

1. **LYNN HAMER**, left, and **MELANIE WAMBOLD**.

2. **LAURA LOFARO FREEMAN**.

3. A 1927 Bugatti.

4. The scene.

5. The spirit of the Riviera.

6. **SUZANNE MURPHY**.

7. The **WAMBOLD** family.

8. **SERENA** and **GILLIAN MINTER**.

9. **SANDRA McCONNELL**, left, and **JEAN REMMEL FITZSIMMONS**.

10. Spiked gloves.

11. **JOE** and **SHEILA FUCHS**.

12. **ELLEN** and **CHUCK SCARBOROUGH**.

13. **ANNE-MARIE** and **DANIELLE SAPSE**.

14. **SIMATON KAMAAMIA**, left, and **LYNN BLUMENFELD**.

15. **TIMOTHY GODBOLD**, left, and **WHITNEY FAIRCHILD**.

16. **SOMERS** and **JONATHAN FARKAS**.

17. **JEAN SHAFIROFF**.

18. **ELIZABETH DENNIS**.

19. **JOY MARKS**.

20. **LUCIA HWONG GORDON**.

21. **KIMBERLY WILKES**.

22. **VERONICA ATKINS**.

23. **MARGO** and **JAMES L. NIEDERLANDER**.

24. **NANCYE SIMPSON** wearing a Bugatti jacket next to a vintage Bugatti.

25. **WESLEY NAULT**, left, and **JORDAN SIEGEL-TRAXLER**.

Aug. 10: Guild H East Hampton w view of Eric Fisch Also on view wer sculptor Elizabet Strong-Cuevas. Her drawings als were displayed.

26. **APRIL GORNIK** and **ERIC FISCHL**.

27. **ELIZABETH STRONG-CUEVAS** in the sculpture garden.

28. **LORINDA** and **MATTHEW ASH** in front of a portrait Ms. Ash.

29. **CINDY SHERMA**

30. **CHAI VASARHELYI**.

31. **STEPHANIE SEYMOUR** in front her portrait.

32. **BARBARA LANE**

33. **ED** and **PAM PANTZER**.

34. The gallery scene.

35. **RONNIE HEYMA** left, and **GLORIA KISCH**.

36. and 37. Ms. Strong-Cuevas with her art.

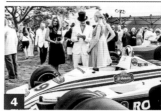

4

5

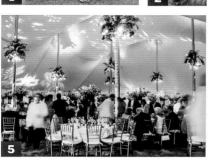

6

7

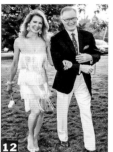

8

9

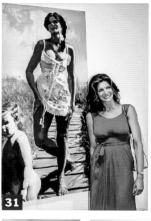

28

29

10

11

31

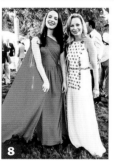

12

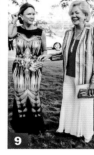

13

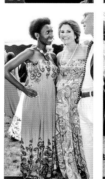

14

15

33

34

16

17

18

19

20

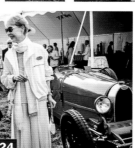

21

22

23

24

25

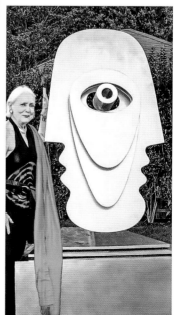

36

37

ummer gala in
exhibition pre-
each Life" show.
works of the

30

32

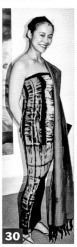

"Lots of stuff to cover this weekend out on Long Island . . . if the railroad doesn't go out on strike!"

—BILL CUNNINGHAM

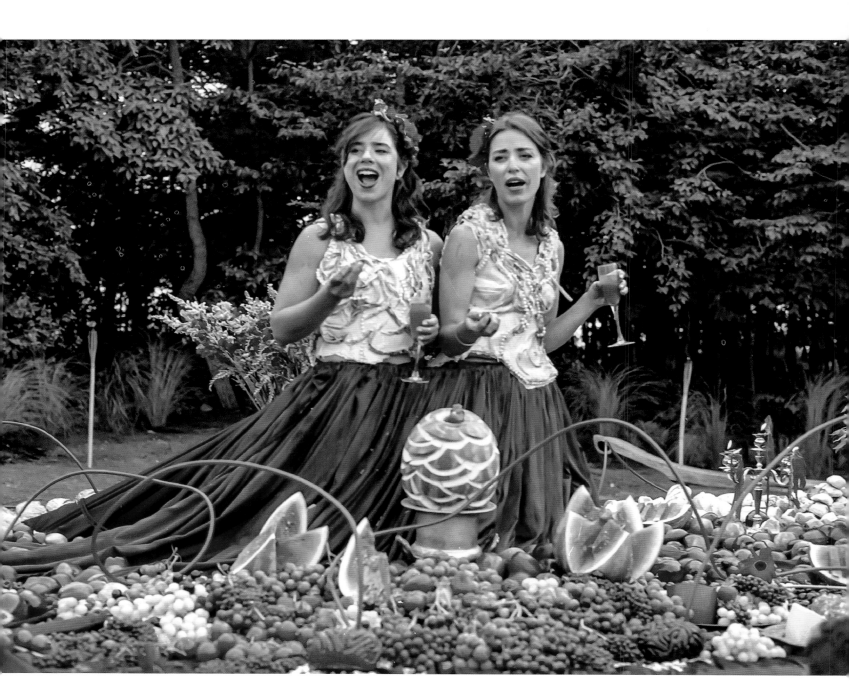

LEFT TO RIGHT Two models serve as a surreal centerpiece for a fruit buffet at the annual Watermill Center benefit, 2005. | Duane Hampton in a flame-colored taffeta dress at the Watermill Center benefit with founder Robert Wilson. | Adair Beutel accepting a bouquet of flowers at the annual Summer Party to benefit Southampton Hospital (now Stony Brook Southampton Hospital), 2000.

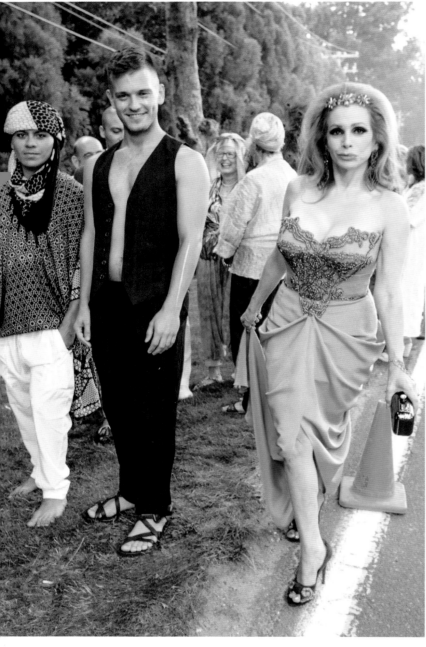

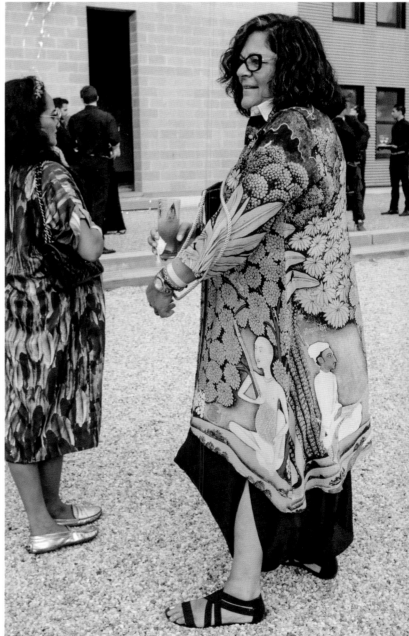

PRECEDING SPREAD Installers construct the entrance centerpiece by set designer Annick Lavallée-Benny at the 2014 Watermill Center summer benefit and auction.

LEFT TO RIGHT Joy Marks arrives at the Watermill Center benefit, with the theme "One Thousand Nights and One Night," 2014. | Fashion insider Fern Mallis at the Watermill Center benefit, 2014. | A horned figure plays the trombone in artist Matt Petty's installation *Eternal Song of the Horned Deity* at the Watermill Center benefit, 2014.

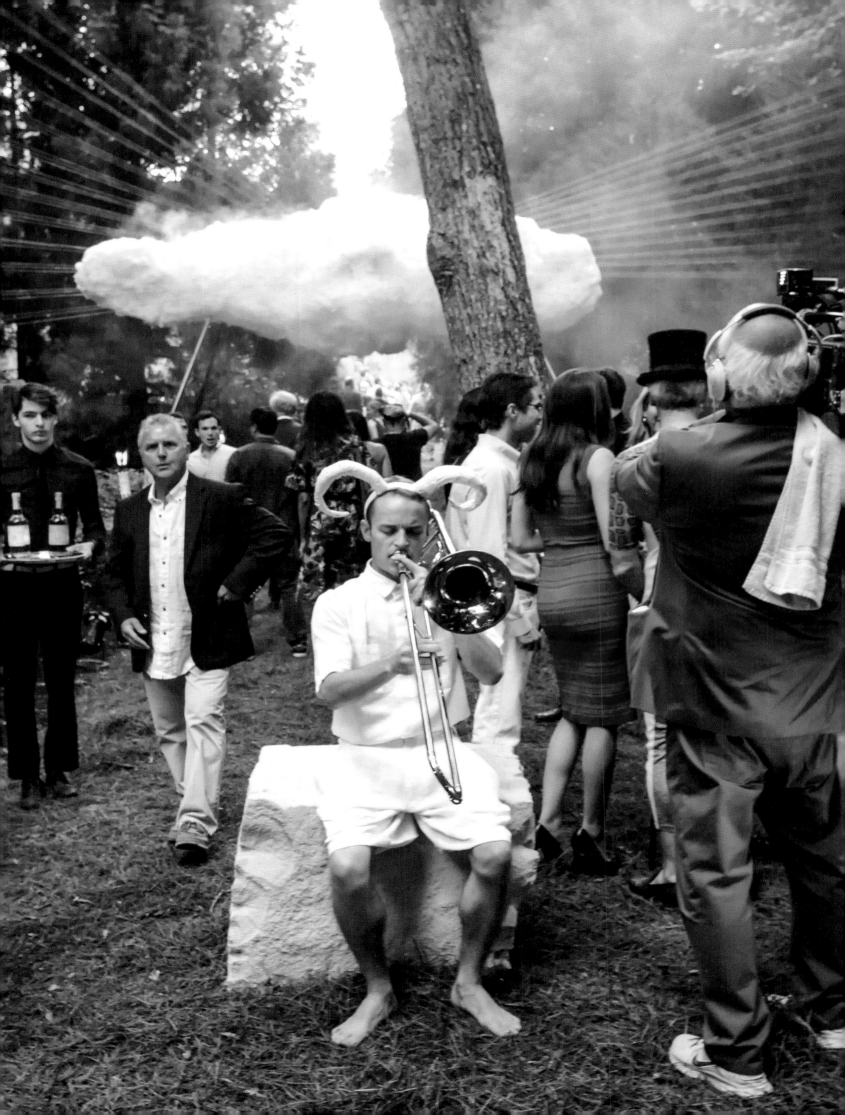

"The women of Southampton have long been identified by their dresses.... There were guests who arrived on bicycles ... And those who came in sporty convertibles."

—BILL CUNNINGHAM

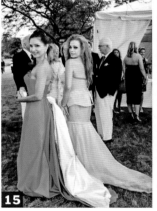

28.
NAE
ing
MAR
riva
ROS
cak
38.

Sentimental Journeys
A benefit in the country, and
a centennial in the city.

Aug. 2: The annual Southampton Hospital benefit was held in a field next to the hospital. The women of Southampton have long been identified by their dresses: white and beige (**1 TO 4**), and powdery colors (**5 TO 7**). These styles are not unlike the village's signature look of hydrangeas, tall hedges, white picket fences and gates (bottom row). **8. ANDREA GIORDANO**, left, and **ELYN KRONEMEYER**. **9. GEORGE WAMBOLD**, left, and **JOHN WAMBOLD**. **10. MARTIN** and **AUDREY GRUSS**. **11. WESLEY NAULT** and **LAURA LOFARO FREEMAN**. **12. DAVID** and **MEGAN RICE**. **13. ELLEN** and **CHUCK SCARBOROUGH**. **14. NANCY STONE**, left, and **JEAN REMMEL LITTLE**. **15. JEAN SHAFIROFF**, left, and **JOY MARKS**. **16. STEPH PAYNES**. **17.** From left, **MARGO MacNABB NEDERLANDER**, **JAMES L. NEDERLANDER**, **JAMES M. NEDERLANDER** and **CHARLENE NEDERLANDER**. **18. KATE KING**. **19. JOHN** and **JUDITH HADLOCK**. **20. DEBRA HALPERT** and **DENNIS McDERMOTT**. **21. LISA ARNOLD**, left, and **MARY UNSWORTH**. **22 TO 24.** There were guests who arrived on bicycles. **25.** And those who came in sporty convertibles. **26. LILIANA CAVENDISH** and her son **EDWARD CAVENDISH**. **27. SANDRA ROSENTHAL**.

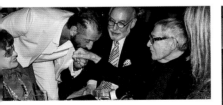

4: The 100th birthday party for Carl Apfel held at La Fonda Del Sol in Midtown.
: **WEBER** and **IRIS APFEL**. **29. LINDA FARGO** and
AN. **30. RALPH RUCCI**, second from left, greeting **APFEL**. **31.** Top row, from left, **EVERETT APFEL**,
ASH and Ms. Apfel, with Mr. Apfel. **32.** The are-
e cake. **33. ADRIENNE bon HAES** and **MARVIN**
DMAN. **34. CLARE** and **REES PRITCHETT**. **35.** The
JENNA LYONS. **37.** Mr. Apfel in birthday glasses.
left, Ms. Apfel and **ISABEL** and **RUBEN TOLEDO**.

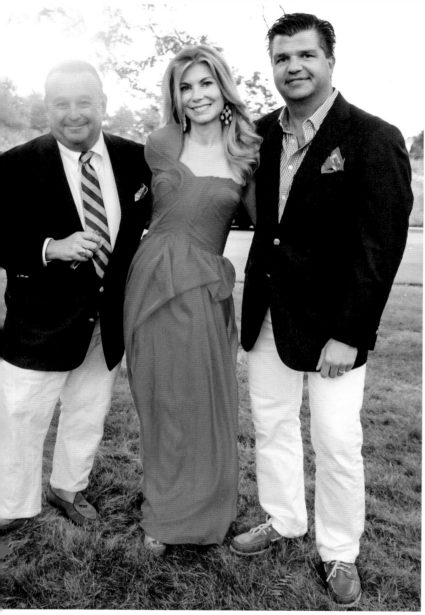

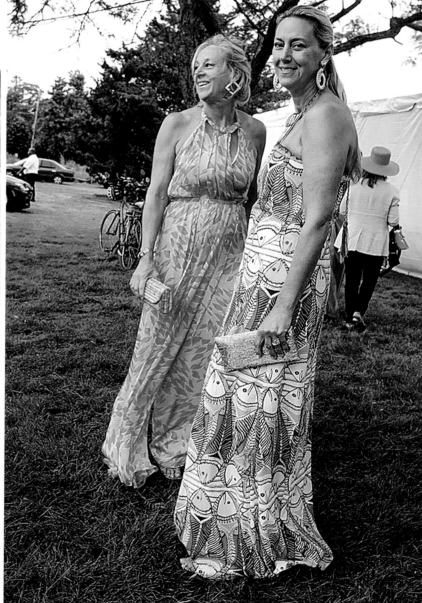

LEFT TO RIGHT At the annual Summer Party to benefit Southampton Hospital, Steven Stolman, party chair Laura Lofaro Freeman, and Rich Wilkie, 2014. | While men typically wear the Hamptons uniform of a navy blue blazer, many women dress in full-on red carpet evening gowns. Sisters Lisa Arnold and Mary Unsworth in printed maxi dresses. | Ladies in their finery gathering in front of the gala tent; the theme of this fifty-sixth annual party was "Endless Summer" and featured a surfer theme.

FOLLOWING SPREAD Jack Schlegel enjoying the unexpected Monet-like garden that Sumner Freeman and Roy Yaeger created at their Fire Island Pines residence, 2014.

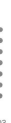

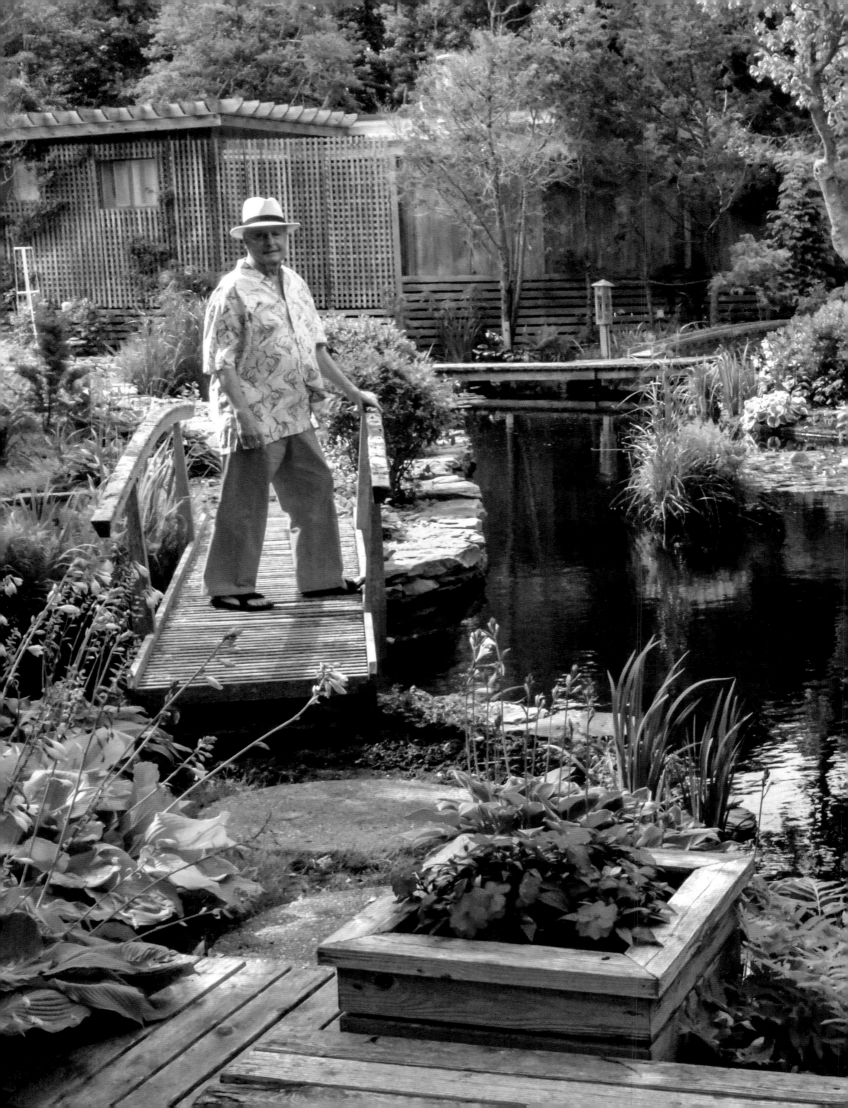

8

Gilded Lives
NEWPORT AND NEW ENGLAND

IN NEWPORT, the grande dame of American summer resorts, Bill found the ultimate fantasy island.

He was always enamored of the Gilded Age, and had an encyclopedic knowledge of the history of the dynastic families that controlled the lion's share of American wealth at the turn of the twentieth century, thanks to such industries as coal, oil, steel, and railroads. And so many of those families built grand houses along the cliffs of Newport.

Many of those houses proved to be too large and too expensive to maintain for modern living, and were either purchased by or donated to the Preservation Society of Newport County, which protects and preserves these historic properties and has made them accessible to the public. In summer, there would be a host of events to celebrate Newport's history and raise funds to support the ongoing efforts of the Preservation Society. Bill loved to photograph the galas held in the ballrooms of the mansions, along with the events surrounding the triennial coaching weekend. Most beloved, though, was the Newport Vintage Dance Weekend, when participants would descend on Newport with trunks of turn-of-the-century clothing and appear in their finery—at

teas, dances, and seaside gatherings. So many of Bill's photographs of these events mimic the paintings of William Merritt Chase, who focused on turn-of-the-century life at the seashore, or portraitist John Singer Sargent, a great many of whose works are displayed at the Isabella Stewart Gardner Museum in Boston, a regular stop on Bill's spring tour of duty.

Similar to his visits to Southampton, Bill's many trips to Newport—often combined with a stop at Marshfield, Massachusetts, where his family summered and still has a beach house—allowed him to cultivate many decades-long, albeit arm's-length, friendships. He knew most of the descendants of the founding families of Newport's summer colony, and photographed them with gusto, along with those in leadership roles at the Preservation Society. In addition, he developed a special affection for those newcomers who undertook extensive rescuing restorations of the great estates. Newport also gave Bill a wider audience, because its population came from many places besides New York, including Boston, the Midwest, Texas, and the West Coast. This depth of knowledge of the social and philanthropic fabric of Newport, combined with his appreciation for both current and historical dress, resulted in lyrical images that blurred the lines between photojournalism and fine art.

Part of Newport's allure is its remoteness. Located at the tip of an island and surrounded by water on three sides, the closest train station is thirty-four miles away. Yet even in his eighties, Bill remained undaunted by the journey. It was as though he was drawn by an unseen force, one that provided him not only with architectural and sartorial expressions that delighted his eye but also a reconnection to his New England roots. No matter how arduous the journey, which involved a rare-for-Bill weekend stay with friends, he returned to the *Times* re-energized and with a special twinkle in his eye. His Newport pages remain some of his best work, as evidenced by the sheer joy and exuberance that Bill usually reserved for the runways of Paris (along with puddles, snowbanks, armloads of flowers at the greenmarket, and young people making their own unique fashion statements). ∎

OPPOSITE *A guest descends the grand staircase at The Elms, one of Newport's grandest mansions, at the Summer Venetian Masked Ball to benefit the Preservation Society of Newport County, 2013.*

FOLLOWING SPREAD *Gala guests enter the foyer of Marble House, another of Newport's extraordinary Gilded Age mansions, 2010.*

PAGES 112–13 *The annual Victorian Dance Weekend in the Massachusetts seaside town of Nahant allowed Bill not only to celebrate his love for vintage dress but also to reconnect with his Boston roots, 2005.*

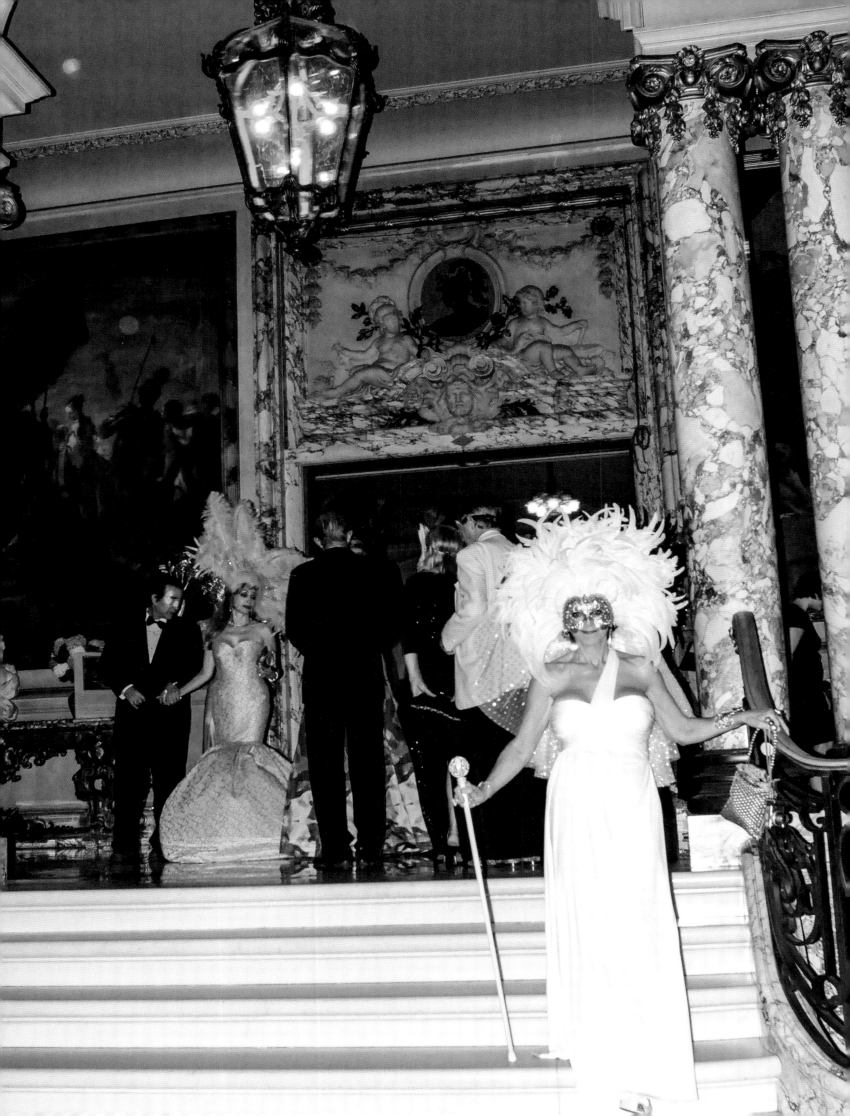

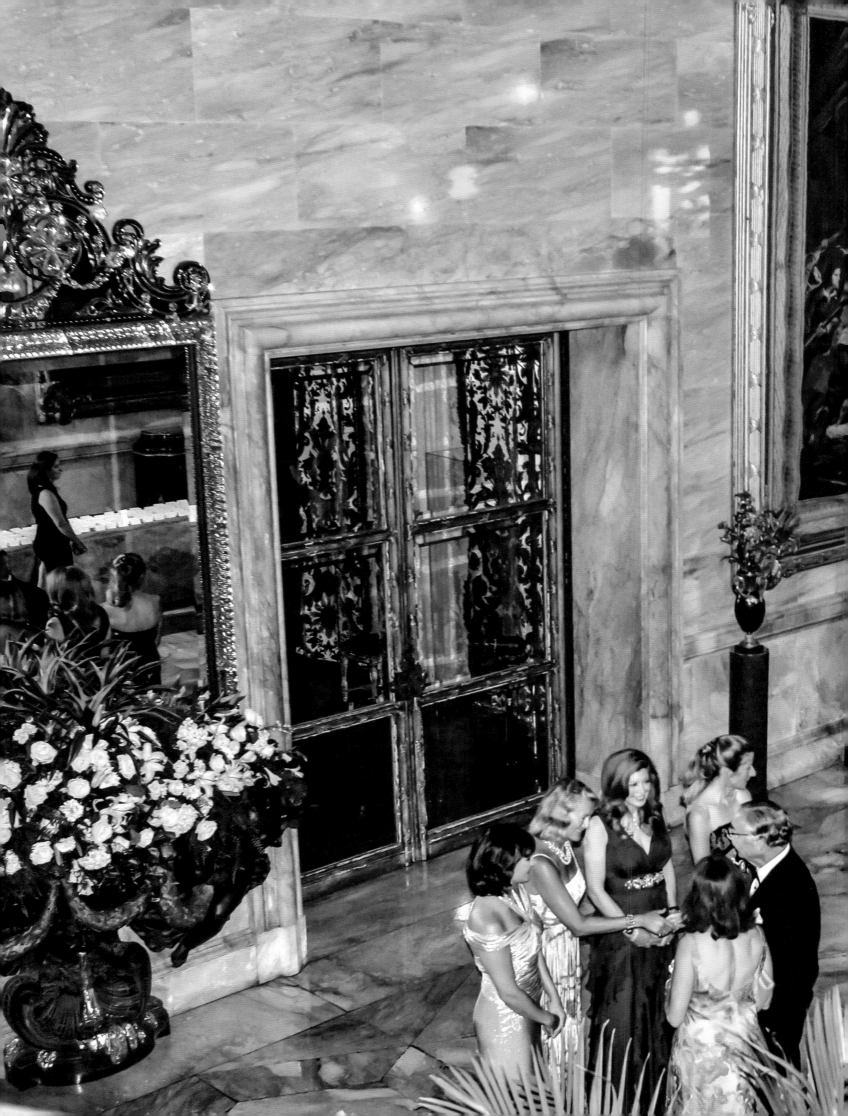

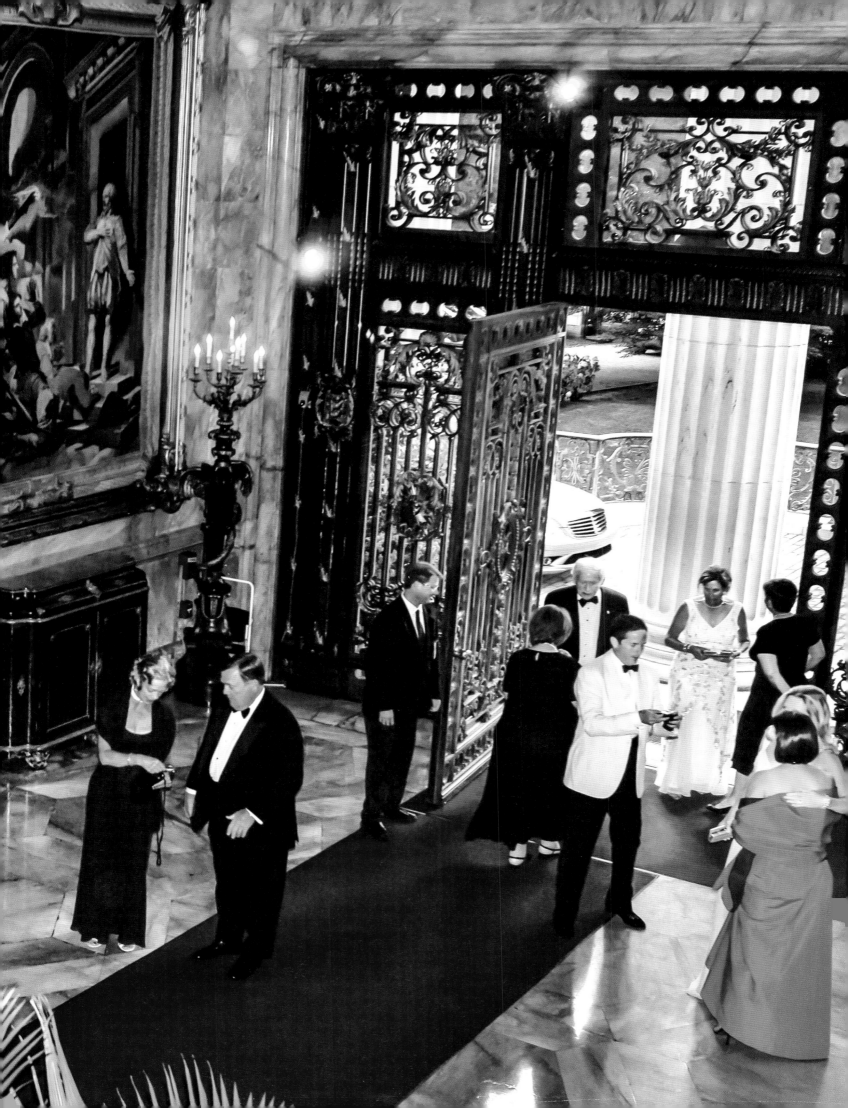

"Guests wore meticulously recreated clothes of the period. Amusing to watch were women backing into cars with enormous Civil-War-era hoop skirts."

—BILL CUNNINGHAM

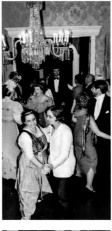

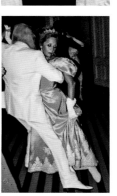

Aug. 7: A
ing took pl
three-day
Nahant Hi
nally crea
nese danc
at the urgi
the Vienne
Costin len
home for t
ian tea da
period clo
Costin hou
and billiar

1

3

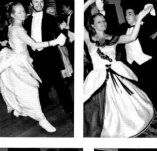
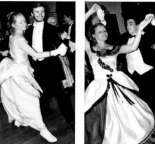
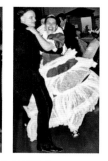
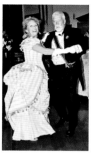
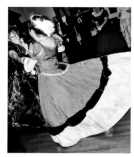

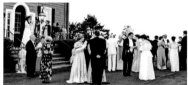
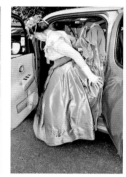

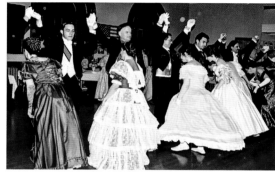
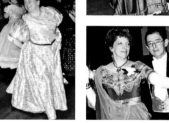

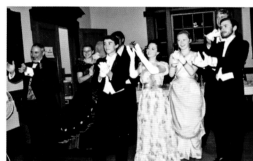

nd of vintage danc-
Nahant, Mass. The
which benefited the
al Society, was origi-
years ago as a Vien-
aty and Ben Bishop
Ms. Bishop's mother,
rn Olli Heil. RoAnn
amily's 1867 seaside
a and the Edward-
ost guests wore
r the dance at the
nich has a ballroom
m.

Aug. 8: The Nahant Town Hall hosted the grand period ball, set in Vienna in the late 19th century. Guests wore meticulously recreated clothes of the period. Amusing to watch were women backing into cars with enormous Civil-War-era hoop skirts. Mrs. and Mr. Bishop, lower left, organized the ball. Guests took turns volunteering to help the nonprofit event run smoothly. Nahant is a seaside resort for prominent Boston families.

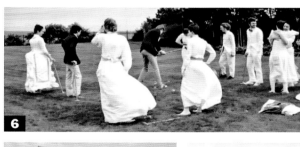
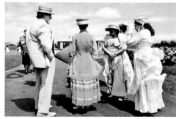

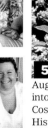

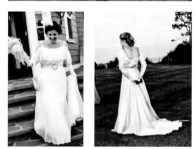

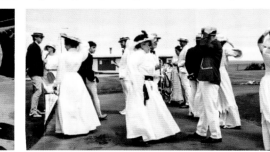

Aug. 9: A party on the lawns of the private Costin estate stepped back into an Edith Warton Edwardian summer. **1.** Four generations of the Costin family. **TOM COSTIN,** second from left, works with the Nahant Historical Society. **2.** Three generations of the Bishop family. **3.** A formal tea. **4. JENNY ELFVING,** the chef, serving lobster salad. **5.** Echoes of John Singer Sargent's paintings of children. **6.** Croquet. **7. ROANN COSTIN.**

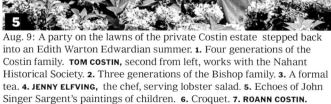
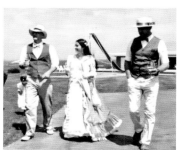
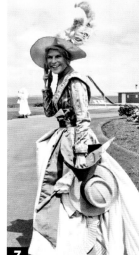

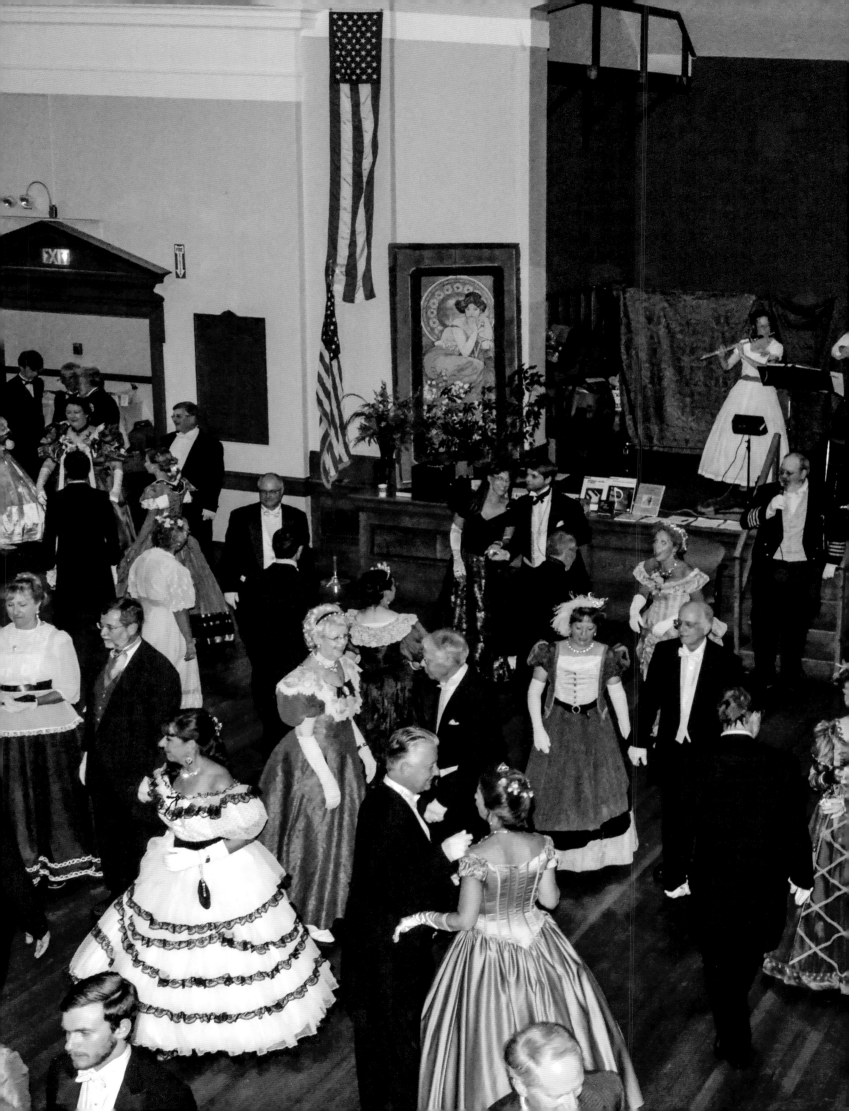

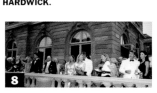

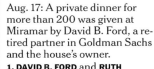

Aug. 17: A private dinner for more than 200 was given at Miramar by David B. Ford, a retired partner in Goldman Sachs and the house's owner.

1. DAVID B. FORD and **RUTH BUCHANAN.**
2. The entrance facade.
3. IRENE AITKEN.
4. The mansion's ballroom.
5. ANN NITZE, left, and **MAUREEN DONNELL.**
6. Some guests came by coach.
7. From left, **PETER D. KIERNAN III, DORRANCE HAMILTON, SIR JOHN RICHARDS** and **EADDY KIERNAN.**
8. Guests on the terrace, where a tent was set for dinner.
9. HELEN WINSLOW and **BOB HARDWICK.**

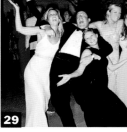

Aug. 18: Peter D. Kiernan III gave a luncheon after Saturday's drive at Hammersmith Farm. He is the current owner of the 90-acre working farm, where John and Jacqueline Kennedy held their wedding reception when it belonged to her stepfather, Hugh Auchincloss.
10. PETER D. KIERNAN III, a former managing director of Goldman Sachs.

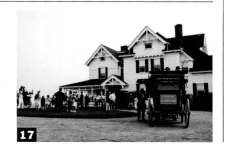

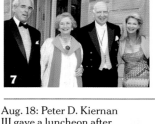

Aug. 19: Lunch at Marble House.
11. RICHARD CHILTON, left, and **FREDERICK PRINCE**, who hosted the lunch.
12. From left, **TUCKER JOHNSON** with **LYNDA, DAVID** and **KENNETH LINDH.**
13. NICK and **JACKIE DREXEL.**
14. OATSIE CHARLES and **EUGENE ROBERTS.**
15. DIANE PRINCE.

Aug. 17: The coaches on an evening drive paused at the Ledges, the compound of the Cushing family, a rambling 1860 house, for a Champagne stop.
16. Members of the Cushing clan greeted the coaches' arrival.
17. The house and the coaches, with the ocean as backdrop.

NEWPORT EVENING HOURS
Bill Cunningham

The evening festivities surrounding the four-day coaching events included drives through some of the estates; above, the crown of the Breakers.

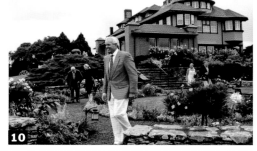

Aug. 16: The opening reception in the stables at the Breakers.
18. Guests arriving at the stables.
19. From left, **LOUIS PIANCONE, TERI PIANCONE, SIR PAUL NICHOLSON** and **DAVID LINDH.**
20. A guest seated in the coach room.
21. NOREEN DREXEL.
22. Arriving by scooter.
23. Guests had drinks surrounded by the horses and hay bales.

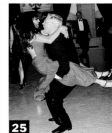

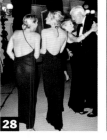

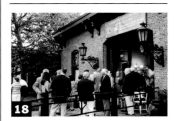

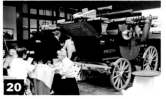

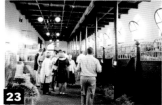

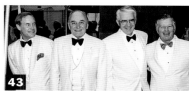

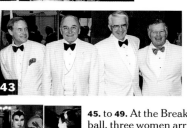

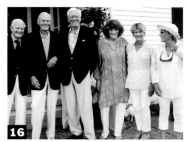

Aug. 18: The weeke[nd] raised $650,000 for [the] preservation of the s[oci]ety's properties. The Breakers ball, held o[n the] final evening, honor[ed] the coaching drivers.
24. to **30.** Fun danci[ng.]
31. From left, **BILL GI[...], FRED HOLANDER** and **TUCKER JOHNSON.**
32. MARY VAN PELT.
33. HOWARD and **MA[...] FAFARD.**
34. MUFFET BLAKE an[d ...] **MURRAY.**
35. DONALD O. ROSS a[nd] **TRUDY COXE.**
36. HILARY DICK and [...] **LIMBOCKER.**
37. GUILLAUME and [...] de **RAMEL.**
38. SHARON and **JOH[N] LOEB.**
39. ALA ISHAM.
40. KATHY and **PIERR[E] duPONT IRVING.**
41. From left, **ARCHIE[...] HELENE VAN BEUREN** [...] **NANCY** and **ALEXAND[...] VON AUERSPERG.**
42. FREDERICK EAYRS [...] danced.
43. The white dinne[r jack]et stars in Newport.
44. From left, **EADDY KIERNAN, MIKE PARK[...] CAMILLA BRADLEY** an[d] **ROBERT MATHESON.**

45. to **49.** At the Breakers ball, three women arrived in the same Monique Lhuillier dress. One did a quick change (**48** and **49**). **ROSEMARY PONZO** (**45** and **46**) noted later: "Have to keep a 'spare' gown in the car. Like a spare tire!"

27

30

34

38

40

42

48 **49**

"The evening festivities surrounding the four-day coaching events included drives through some of the estates."

—BILL CUNNINGHAM

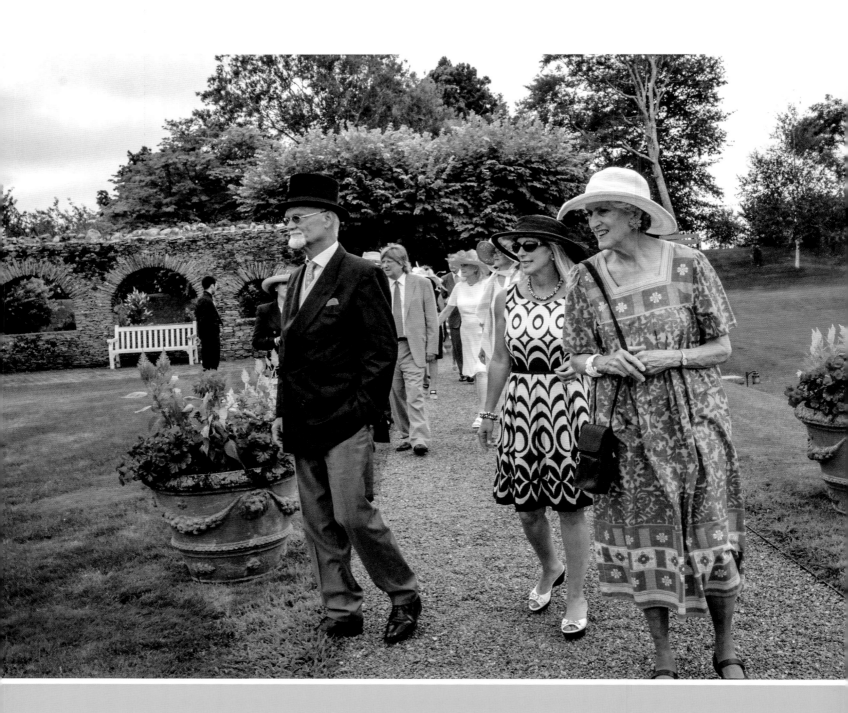

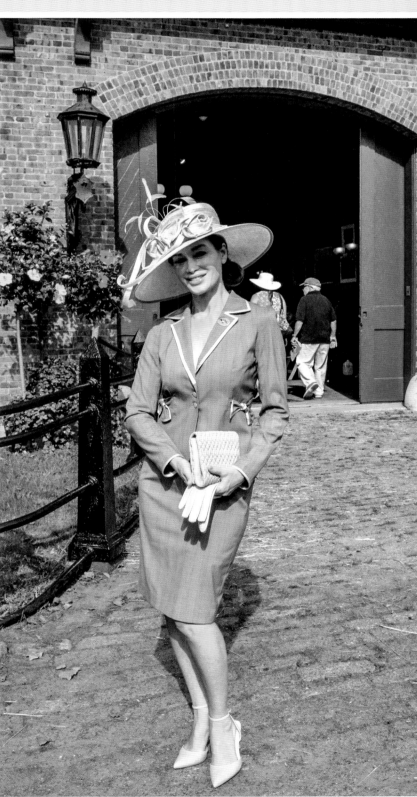

LEFT TO RIGHT Coaching Weekend luncheon guests at Hammersmith Farm, 2015. | Peter Kiernan III, owner of Hammersmith Farm, calls guests to lunch with a brass bell. | A hatted and suited luncheon guest at the carriage house at The Breakers.

FOLLOWING SPREAD A full coach, ready for the procession at The Ledges, the Cushing family compound overlooking the Atlantic, 2015.

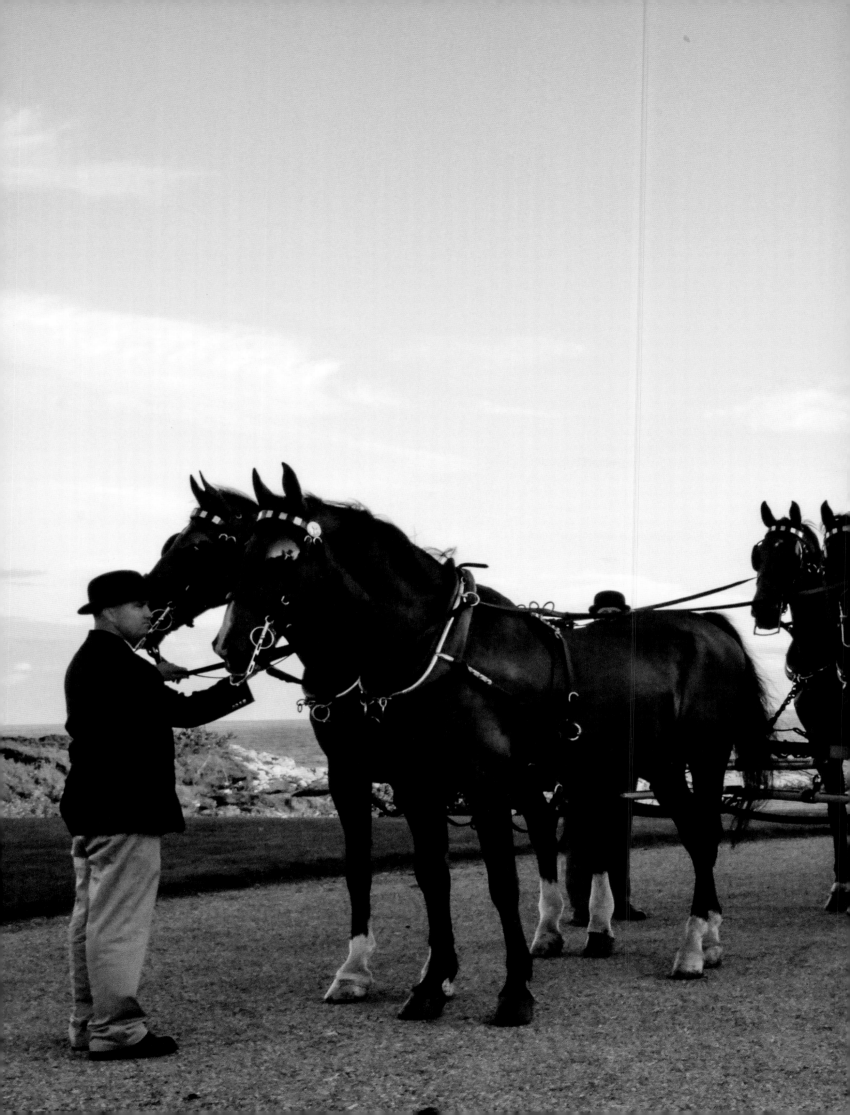

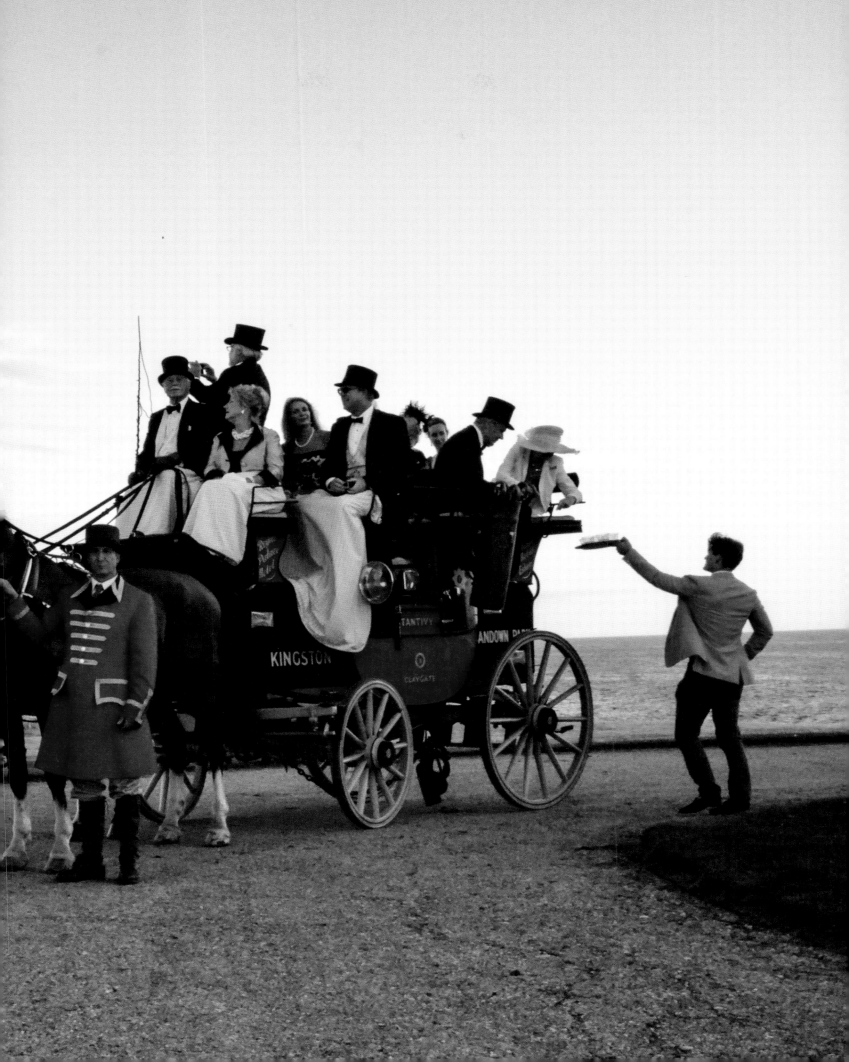

"The committee spared no detail with the evening," reminiscent of the opening party of the teahouse at Marble House, in 1914." —BILL CUNNINGHAM

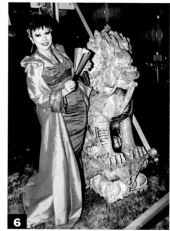

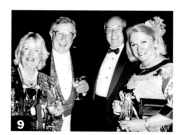

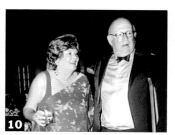

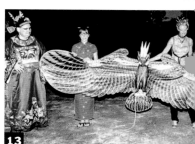

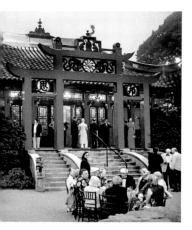

Dragon's Den

A foggy summer night in Newport.

Aug. 13: The Preservation Society of Newport County held its 60th anniversary ball at the teahouse on the grounds of Marble House, one of the society's fabled Vanderbilt mansions. The Dynasties and Dragons dinner for 600 guests was held on the lawn under a tent hung with 408 Chinese lanterns. The committee spared no detail with the evening, reminiscent of the opening party of the teahouse, in 1914. Under the tent five pavilions were decorated in opulent dynasty themes. A cocktail reception for 50 V.I.P.'s in the teahouse preceded the larger cocktail party on the terrace of Marble House.

1. **MICHELE FOSTER**, one of the many guests in Chinese dress.
2. The teahouse, built in 1913, was completely restored in 1977.
3. Inside the teahouse, lighted by bronze lanterns.
4. **KIM HERRLINGER**, a chairwoman of the evening.
5. **CYNTHIA GIBSON**, who designed the tent, a tour de force.
6. **ROSEMARY PONZO**, with one of the many garden statues.

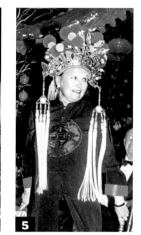

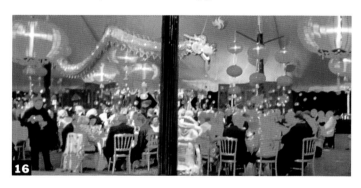

7. **MAUREEN DONNELL**.
8. **ELIZABETH LEATHERMAN** and **MICHAEL KISSEL**, dancing to Bob Hardwick's music.
9. **LYNDA LINDH**, left; **DAVID E. P. LINDH**; **JOHN J. SLOCUM JR.**; and **DIANA SLOCUM**.
10. **ELIZABETH PRINCE DE RAMEL** and **FROLIC WEYMOUTH**.
11. **TOPSY TAYLOR**.
12. **DIDI LORILLARD COWLEY**, left, and **KATHY duPONT IRVING**.
13. **TOM CASSELMAN**, left, with guests, launching his kite.
14. **JANE** and **PETER ELEBASH**.
15. A dragon slithering through the air.
16. The dinner tent.
17. **LES** and **CAROL BALLARD**.
18. **ANN NITZE**, left, **MARTHA HYDER** and **NANNETTE HERRICK**.
19. From left, **EADDO KIERNAN, PETER KIERNAN** and **SANDRA WHITEHOUSE**.
20. **MIKKI MICARELLI**, left, and **JEAN DIBOMA**.
21. **JOHN G.** and **HELEN WINSLOW**.
22. **DEBBY KRIM**, pretending to pull a jinrikisha, with **RYAN KENNER**, back left; in it were **WINI** and **ROBERT GALKIN**.
23. The lion dance on the terrace.
24. **RICHARD** and **PHYLLIS HIGGERSON**.
25. **DAISY PRINCE**, left, **COLIN McKENZIE** and **HUGH CHISHOLM**.
26. **LISA T. STUBBS**, in a tasseled headdress.
27. **SALLY PHELPS**, in a silver headdress.
28. **JULES MOORE** and **DAVID HERRLINGER**.
29. **ROBERT MATHESON** and his grandmother, **RUTH HALE BUCHANAN**.
30. From left: **BERNADETTE LIRAKIS, ANNE ROBERTS, EUGENE B. ROBERTS JR., LYNN ROBERTS** and **PIERRE duPONT IRVING**.

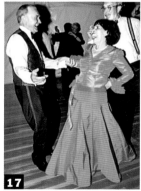

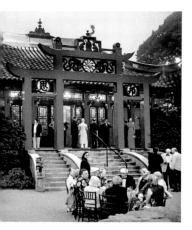

9

All That Jazz

GOVERNORS ISLAND AND LINCOLN CENTER

HEIDI ROSENAU, the associate director of communications and marketing for the Frick Collection, along with her husband, Joe McGlynn, were members of Bill's inner circle—those creative types and "kids" whom he adored. A vintage fashion enthusiast, Heidi began dressing exclusively in vintage clothing, mostly from the 1930s and '40s, during her high school years in Hillsboro, California, outfitting herself from the thrift shops that lined San Francisco's Haight and Polk Streets.

A longtime museum media-relations professional, Rosenau worked at the Guggenheim in the 1980s, but didn't really understand who Bill was at that time. "We'd let him into our events but, honestly, without understanding his importance. A few years later, I invited him to a photography event that he couldn't attend due to one of his early bicycle accidents," she remembers. While working at the National Academy of Design, she had direct contact with the press, and that included Bill. A devoted swing dancer, she approached Michael Arenella, the

leader of the Dreamland Orchestra and the force behind the Jazz Age Lawn Party, and told him, "This Governors Island gig you have is really significant. I'd love to see if Bill Cunningham will come out for this." Bill did, and he cast an extraordinary spotlight on the event and on Governors Island. He missed it only every third year when he went up to Newport for coaching weekend. But otherwise, he was at every single Jazz Age Lawn Party— even when he was unwell. He loved the event and—in typical Bill fashion— would go from the jazz party right out to the Hamptons to cover more festivities the very same day.

Bill's fascination with vintage fashion and dance revealed him as not only the perpetual student of fashion history but also the ultimate Peter Pan. Throughout his long life, he maintained a childlike demeanor that was in marked contrast to his patrician appearance. This youthfulness was reinforced by regular contact with young people and the events they attended. New York's summer schedule of vintage-themed events has always enjoyed a strong following among twenty- and thirtysomethings, as those at the beginnings of their adult

city lives tend to remain in the city on weekends rather than make the Friday night exodus to the Hamptons or Upstate, which is the routine for their slightly older counterparts. While his Hamptons and Newport work tended to echo the paintings of John Singer Sargent and William Merritt Chase, his "Summer in the City" archive has strong references to the style of French impressionist painters such as Pierre-Auguste Renoir, Georges Seurat, and Edgar Degas. While it's doubtful that Bill deliberately attempted to mimic these artists of another time and place, his knowledge of art history and lifelong affection for art museums and French culture certainly played a subconscious role in his photography. ∎

OPPOSITE *Vintage-dress enthusiast Heidi Rosenau, shown here in 2014, consistently delighted Bill with her carefully considered, authentic ensembles. She introduced Bill to the Jazz Age Lawn Party on Governors Island, which Bill adored.*

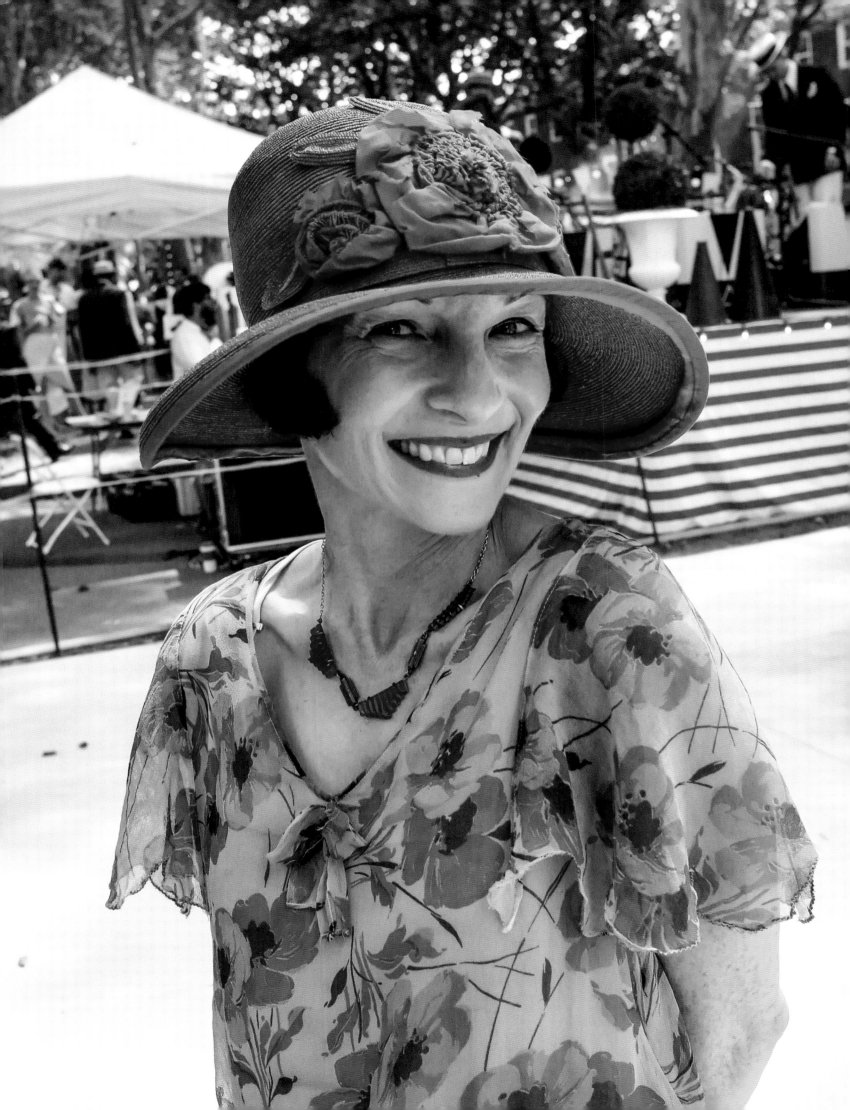

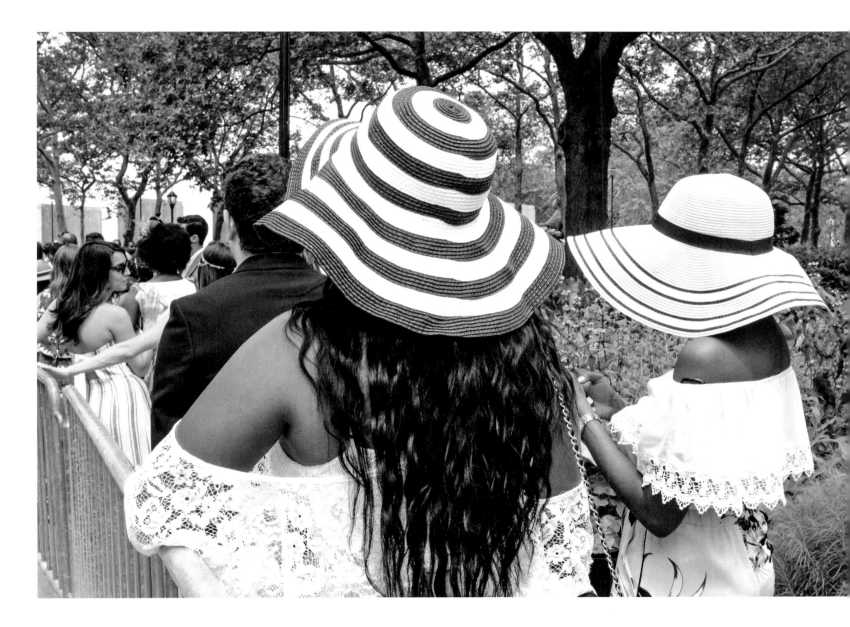

LEFT TO RIGHT Not all attendees dressed in Jazz Age style—many wore festive summer dresses. | An interesting hat always caught Bill's eye, such as this architecturally tiered straw saucer worn with a strapless romper in the same blue as Bill's beloved French workman's jackets. | Even among the youthful, casual crowd, Bill found a striking black-and-white striped moment.

FOLLOWING SPREAD At first glance, it's a group of attractive ladies. Bill, however, would find interest in a subtly underlying theme. In this case, many of the dresses or handbags feature some manner of a floral motif.

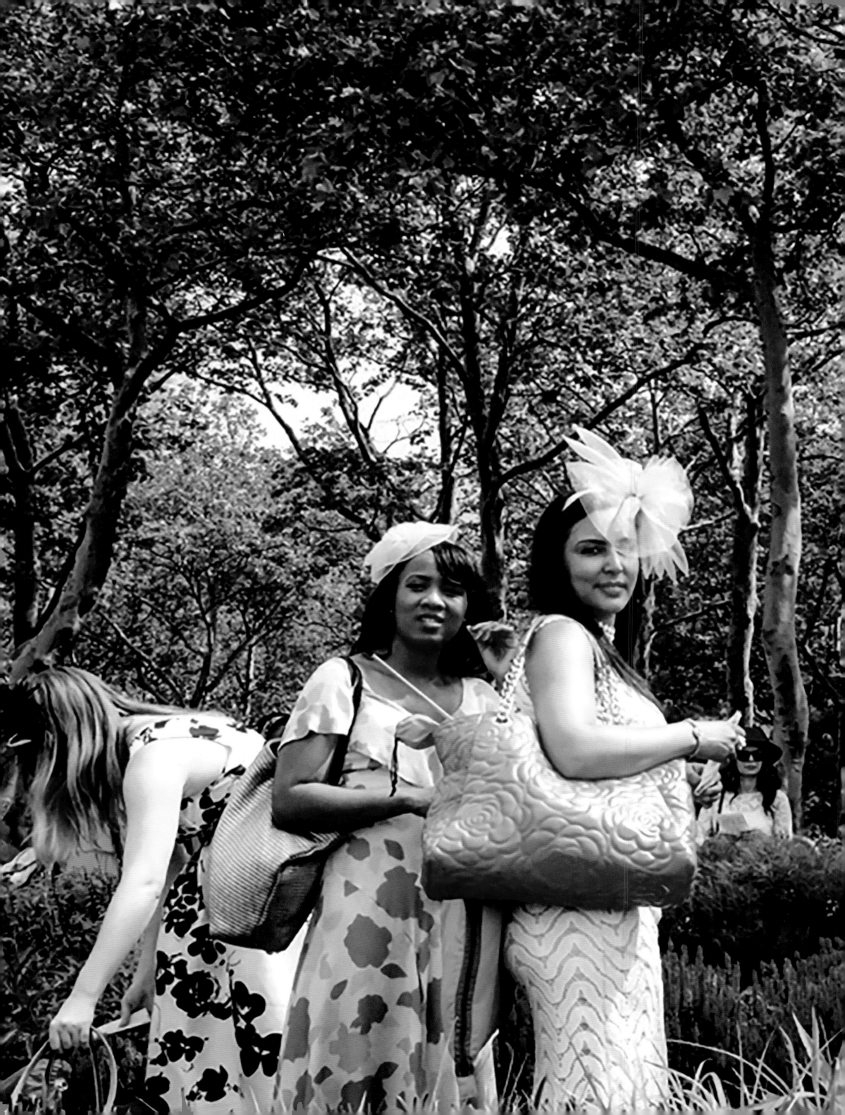

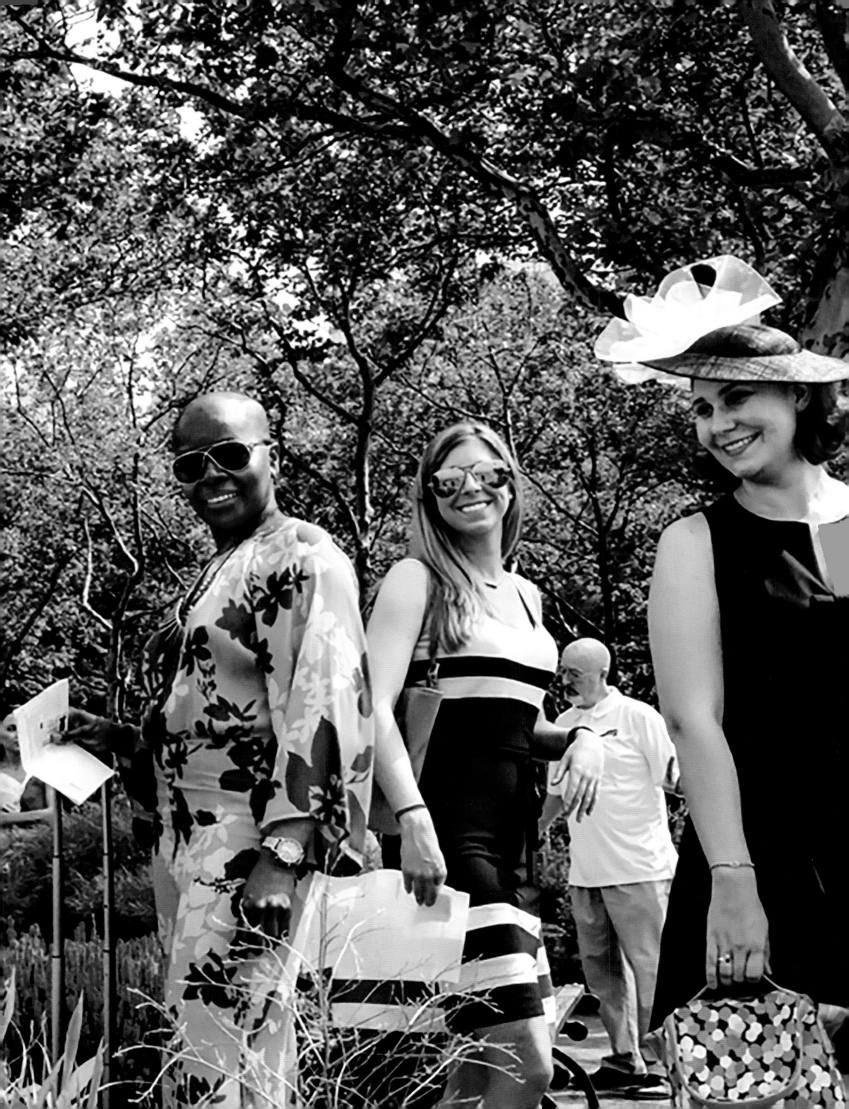

"Many came to picnic and to be part of the spectacle rather than to dance. For others, it was an escape into the illusion of the Roaring Twenties."

—BILL CUNNINGHAM

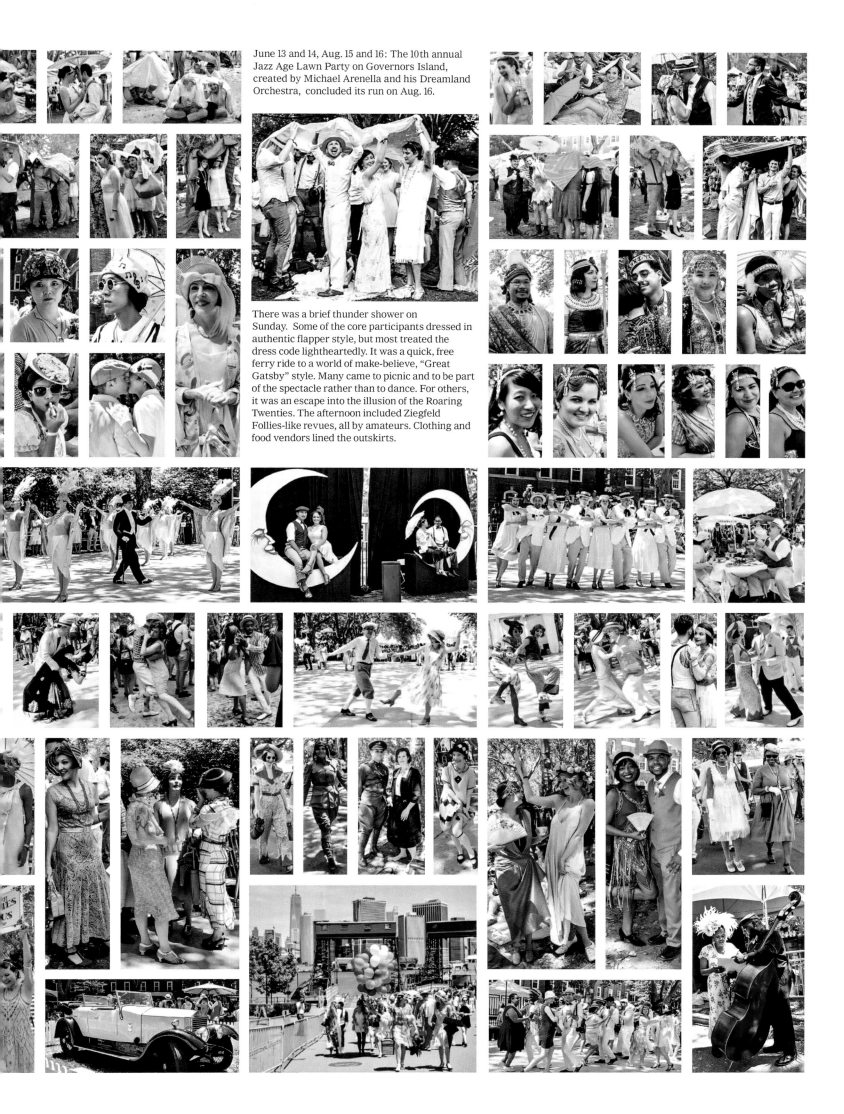

June 13 and 14, Aug. 15 and 16: The 10th annual Jazz Age Lawn Party on Governors Island, created by Michael Arenella and his Dreamland Orchestra, concluded its run on Aug. 16.

There was a brief thunder shower on Sunday. Some of the core participants dressed in authentic flapper style, but most treated the dress code lightheartedly. It was a quick, free ferry ride to a world of make-believe, "Great Gatsby" style. Many came to picnic and to be part of the spectacle rather than to dance. For others, it was an escape into the illusion of the Roaring Twenties. The afternoon included Ziegfeld Follies-like revues, all by amateurs. Clothing and food vendors lined the outskirts.

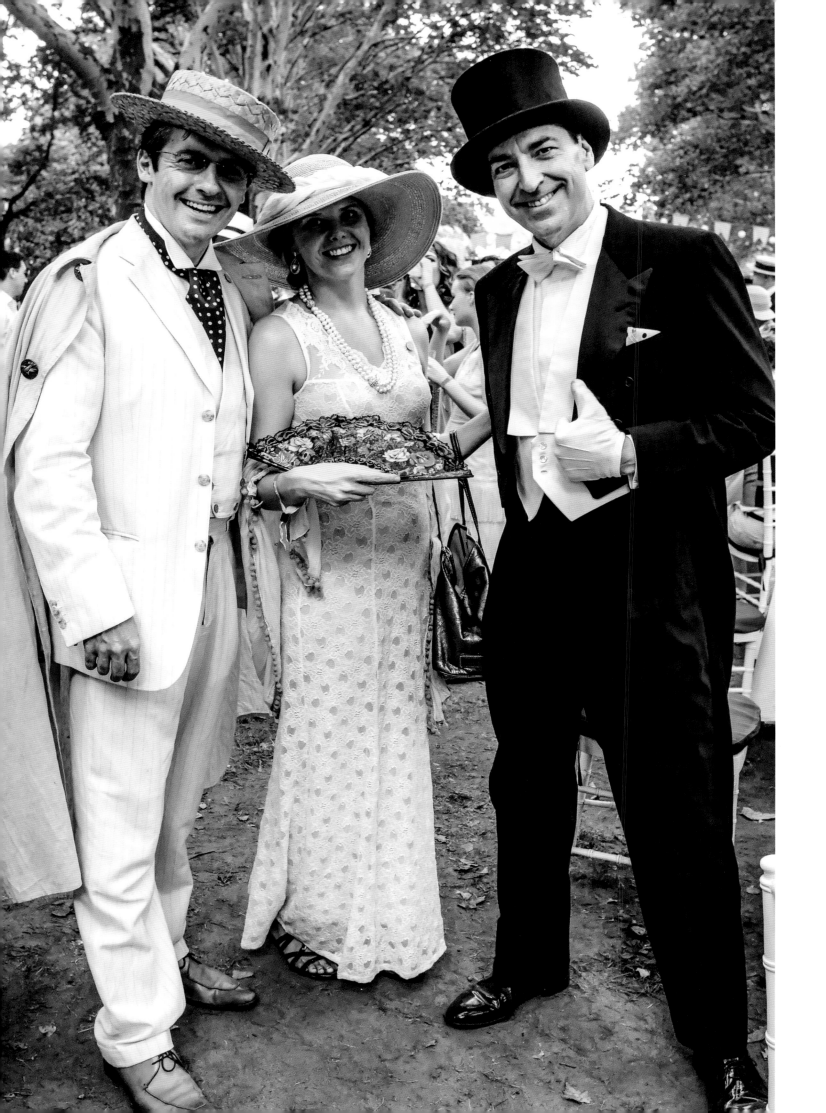

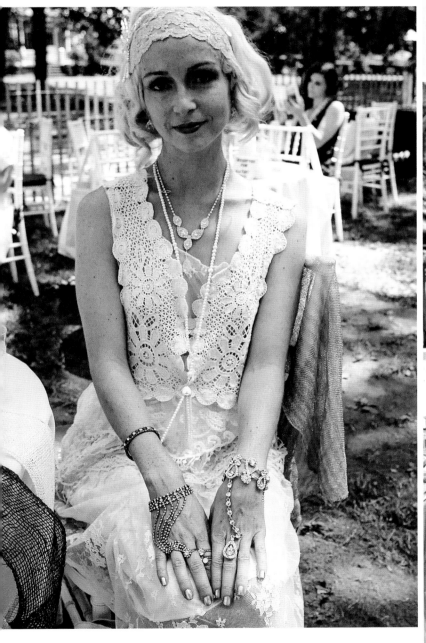

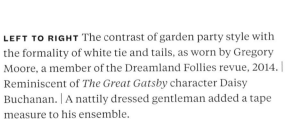

LEFT TO RIGHT The contrast of garden party style with the formality of white tie and tails, as worn by Gregory Moore, a member of the Dreamland Follies revue, 2014. | Reminiscent of *The Great Gatsby* character Daisy Buchanan. | A nattily dressed gentleman added a tape measure to his ensemble.

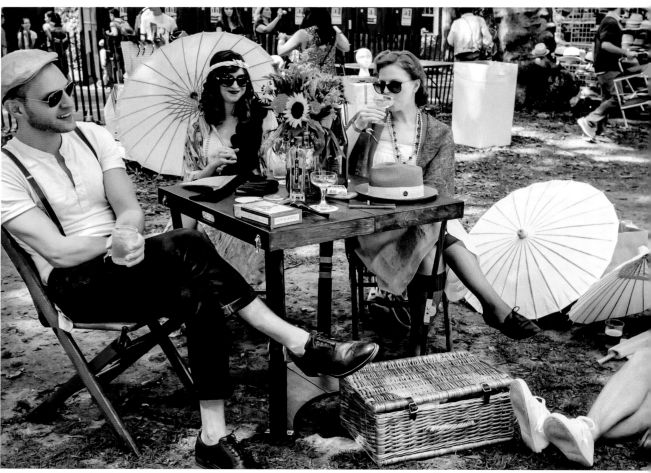

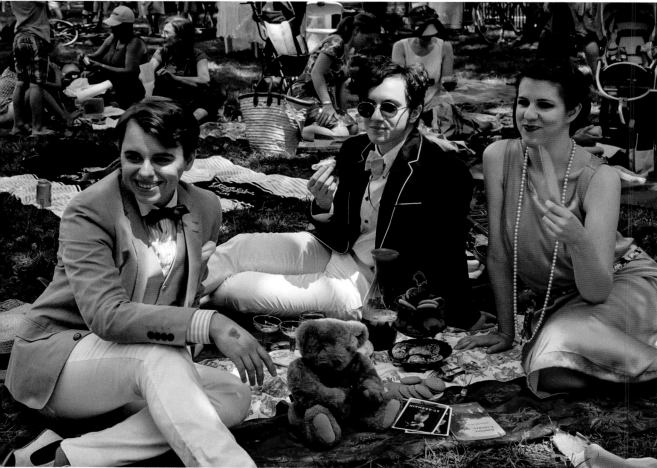

ABOVE Chinese paper parasols add an exotic touch to a group equipped with their own vintage card table, at the Jazz Age Lawn Party.

LEFT Picnickers took great pains to create vintage vignettes, even bringing a teddy bear for a *Brideshead Revisited* aura.

OPPOSITE Many attendees sported outfits associated with English country gentry.

FOLLOWING SPREAD Lincoln Center's Midsummer Night Swing is a three-week festival held in Damrosch Park. Spanning the Jazz Age to the 1940s in both music and dress, it is one of the biggest outdoor dance parties of the summer. Heidi Rosenau, at left, dances with her husband, Joe McGlynn, 2015.

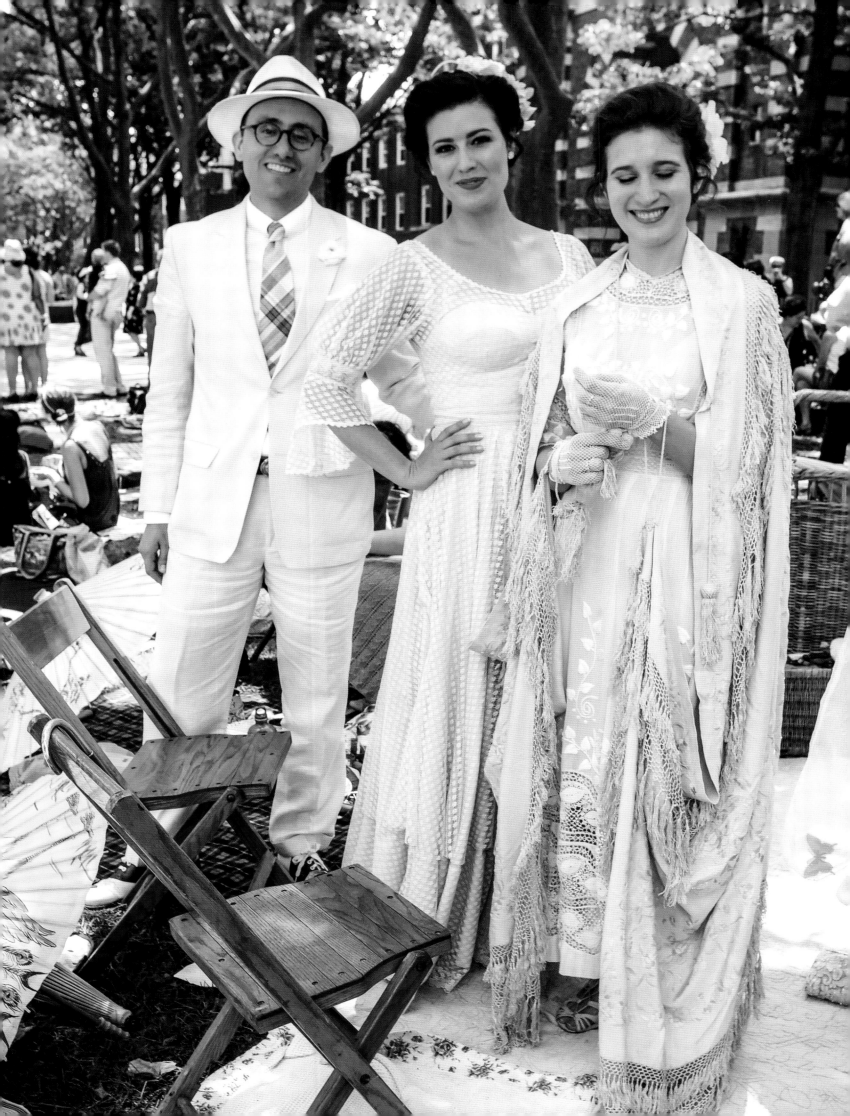

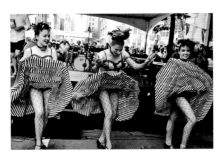
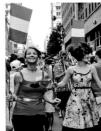

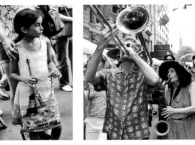

July 12: The annual Bastille Day street festival, which stretched from Fifth Avenue to Lexington Avenue on 60th Street, brought out can-can dancers, street musicians and vendors of French pastries.

July 12: The dancing figures in three paintings from 1883 by Auguste Renoir, shown at the Frick Collection in 2012, are now dancing on Broadway and 39th Street, thanks to Seward Johnson's sculpture exhibition. Youngsters took a ride on the train of a gown. At Lincoln Center, a woman dancing with a fan, left, echoed Renoir's dancer with a fan.

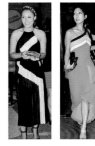

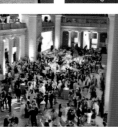

July 9: More than 1,200 guests attended the Metropolitan Museum of Art's Young Members Party in the Great Hall. They also visited the John Singer Sargent show.

Footloose in the City

Summer nights bring out the dance spirit.

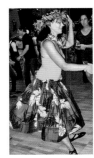

July 3: As part of Lincoln Center's Midsummer Night Swing series of outdoor dancing and live band performances, the music group Kahulanui performed Hawaiian swing. Many of the guests wore Hawaiian-theme cloth[es] including hula skirts. Most popular we[re] fresh flowers worn in the hair. There w[as] a '40s Hawaiian fashion contest. Peopl[e] arranged themselves into lines for hula dancing.

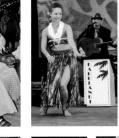

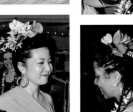

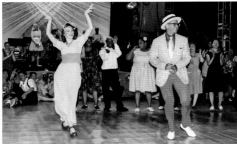

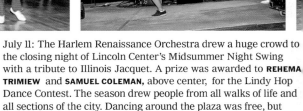

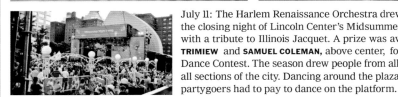

July 11: The Harlem Renaissance Orchestra drew a huge crowd to the closing night of Lincoln Center's Midsummer Night Swing with a tribute to Illinois Jacquet. A prize was awarded to **REHEMA TRIMIEW** and **SAMUEL COLEMAN**, above center, for the Lindy Hop Dance Contest. The season drew people from all walks of life and all sections of the city. Dancing around the plaza was free, but partygoers had to pay to dance on the platform.

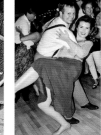
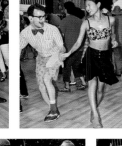

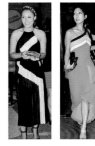

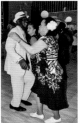
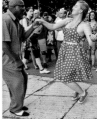
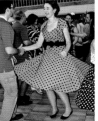

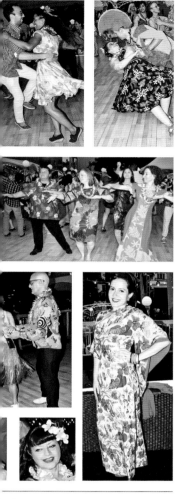

"I let the street talk to me. I try to find what's honestly there. . . . I just enjoy life and enjoy what I do."

—BILL CUNNINGHAM

A New York Story

STEVEN STOLMAN

WHEN I GRADUATED from Parsons School of Design in New York with a degree in Fashion Design, there wasn't a decent Seventh Avenue job to be had. Due to the soft economy in the late 1970s, none of the big-name houses were hiring, as opposed to past years when Parsons grads would traditionally fan out to the hot sportswear companies, such as Anne Klein, Calvin Klein, Ralph Lauren, and Perry Ellis, with ease. That didn't really matter to me, as I wanted to be a dress designer in the grand old tradition of Norman Norell and Pauline Trigère. But Norell was out of business and Trigère wasn't hiring, even though Trigère herself was my senior-year design critic and I had won the Pauline Trigère Gold Thimble Award for a dramatic double-faced wool cape. The only job offer I received was from Omniform, a division of the Jones Apparel Group, one that manufactured "soft home products." Even worse, I would be assigned to a newly acquired license: The Muppets. Goodbye, sequined evening gowns; hello, Kermit oven mitts and Miss Piggy toaster covers.

I made a last-ditch attempt at a real Seventh Avenue job and sent a wildly creative résumé to Pearl Nipon, the designing half of the dress duo Albert Nipon. After my first miserable day on the Jones job, I arrived home to a letter in my mailbox from Pearl. "Everyone likes to start their day with a laugh, and your résumé did just that." I decided to take my chances and told the Omniform people the next day that I didn't think the job was for me, and fortunately, before I knew it, I was offered a job at Nipon: not as a designer but as the New York assistant to the Philadelphia-based director of public relations—a strait-laced gal who hated me from the get-go. I lasted barely a year, but in the early 1990s was rehired, more than a decade later, in true *All About Eve* fashion, as design director. Seventh Avenue is full of stories like that.

In between, I tried to launch my own label with family backing (which failed), took a job designing garden-party dresses out of floral chintz for Lord & Taylor, and was offered my own label yet again, but this time with the support of a sizable dress company. That worked, and soon my dresses were flying off the racks of Saks Fifth Avenue, Bergdorf Goodman, and more avant-garde stores such as Barneys New York. We dressed Tipper Gore and Katie Couric and, best of all, Jean Smart for her role as Charlene on television's *Designing Women*. It was during that gig that I had my first encounter with Bill Cunningham.

Sometime in the late 1980s, as the fashion industry was being ravaged by the AIDS epidemic, I was asked to create a Valentine to be auctioned off at one of the seemingly weekly benefits for amfAR, the Gay Men's Health Crisis, and other organizations desperately trying to do what the government wouldn't: raise funds for research, care, and most important, a cure. I took an ordinary drugstore candy box shaped like a heart and replaced all of the chocolates with heart-shaped jeweled buttons, hot-glued right into the little brown-paper frilled wrappers, which were in turn glued into the box. I was pleased with the results, and remember going to the party at the Puck Building and enjoying seeing people actually bidding on my creation.

About a week later, I received a random manila envelope—I actually think it had been used before, with the previous recipient's name and address scratched out and replaced with mine. Inside: a dramatic eight-by-ten, black-and-white glossy print of my candy box with a note attached: "Dear Steven, What a marvelous Valentine you have created! If it were up to me, this photo would have run in the *Times*. Sincerely, Bill Cunningham." And that was my very first interaction with the gentle genius.

Over time, I would see Bill on the job at various events. I wasn't particularly attractive nor was I an "A-list" designer, so I never expected to catch his eye.

But all of that changed when I opened a little shop in Southampton and began making women's clothing out of fabrics traditionally used for upholstery and curtains. This was nothing new. I knew Oscar de la Renta and Bill Blass frequently used fabrics from such august textile houses as Brunschwig and Scalamandré. But my designs struck a responsive chord with the smart set and—somehow, someway—with Bill, too. Suddenly, I was showing up in his pages, as big as the Michelin Man, twirling some gal on some dance floor. I would always cringe, and ultimately cut back on the food and booze and got on the treadmill. It helped a little. But my seminal Bill Cunningham moment happened in 1999.

I was itching to do evening-wear, even in a beachy town like Southampton. I was able to find an affordable silk taffeta resource that had lots of pretty colors, many with iridescent effects. I thought that if we made big, billowing ball skirts with pockets, my customers might like them to wear with a man-tailored white shirt or even a T-shirt for summer parties. The skirts took off, and one year at least twenty women wore them, or dresses that incorporated those skirts, to the big Southampton Hospital Summer Party. I couldn't believe my eyes when I opened the *New York Times* Sunday Styles section the following week. There, in blazing color, Bill's entire page was devoted to those skirts (see

pages 60–61). I was over the moon.

A year later, at the very same party, several men wore trousers that I had made from the same fabrics I was using for women's skirts, dresses, and pants. Bill was there, and he noticed. I saw him wandering through the tent and across the dance floor, crouching here and there like a tiger stalking its prey. The party was on a Saturday night, and that following Wednesday my mobile phone rang. "Hello, young fella. This is Bill Cunningham." How he got my number remains a mystery, but he went on to tell me how much

he loved my work and did I know that he too had a shop in Southampton and that I reminded him of Shep Miller, the renowned clothier who introduced colorful menswear to the Hamptons back in the 1950s. I was completely floored. But that was nothing compared to the second full page that he devoted to my designs—this time, all men in my printed pants. To this day, that remains one of my proudest moments. But Bill even managed to top that.

ABOVE *Steven Stolman and John Kurdewan at the Central Park hat luncheon, 2018.*

I left the fashion business rather suddenly, due to the inability to resolve a business dispute with my supposedly silent partners. It was a heartbreaking, gut-wrenching experience—walking away from what I had built—but it was essential to my survival. I found work raising money to build a nonprofit community health center for the uninsured, and I loved it. And one day, a curious little postcard showed up in my mailbox. It was from Bill.

Dear Steven,
What a tremendous change in your
life, from fashion to building a health
center for the uninsured. What a noble
dedication on your part, but one that
will bring you greater satisfaction.
Fashion as we know it is drastically
changing to pure commerce. You
enjoyed the golden age. Treasure your
happy outlook on life.
Fondly,
Bill Cunningham

While I was working for the nonprofit, the Lilly Pulitzer company asked me to curate a retrospective of Lilly's designs for their fiftieth anniversary "Jubilee" (a name that I gave it, pretentious Anglophile that I am). Thus began a gentle return to the business that I loved. Following my work for Lilly Pulitzer, I was hired to serve as design director of the newly energized Jack Rogers brand, which in turn led me to the unlikely position of president of Scalamandré, the renowned textiles house, which I held for three years.

While I had very little experience with the discipline of interior design,

save for being friends with an awful lot of decorators, I loved it and approached the job in much the same way I did any of my previous fashion industry gigs—developing a brand, building collections, and initiating licensing opportunities. I felt that Scalamandré was part and parcel of the New York story, given its founding in Long Island City in 1929, so I was especially pleased when we were asked to create and donate the tablecloths for the Central Park hat luncheon, which the company has continued to do.

One of the benefits of providing the tablecloths, which were sold to benefit the conservancy, was a ticket to the luncheon. Of course, I enjoyed seeing the fashions and hobnobbing with the city's leading ladies. Bill was always there, obviously, as this event was and remains a centerpiece of the spring social calendar. In addition, the hats captivated both him and his camera, drawing on his early years as a milliner.

One year, I was seated next to Alexandra Lebenthal, daughter of the late, legendary municipal bond salesman James Lebenthal and one of Bill's favorite gals to photograph, as she was always among the best dressed at any event. We chatted about the upcoming Conservatory Ball to benefit the New York Botanical Garden, another quintessential New York event that traditionally brought out the grandest gowns, usually with a floral theme.

Alexandra, knowing of my past life as a fashion designer, asked if I could make a dress for her—something special that no one else would have. I couldn't resist, thinking about a new Scalamandré silk taffeta inspired by a Mary Cassatt painting, and quickly sketched a dress on the back of a place card. "I love it!" she exclaimed. A few weeks later, I delivered the dress to Alexandra's office.

I was lucky enough to have attended the gala that year, and needless to say, Alexandra was the belle of the ball. Bill was there too, and was enchanted by the way the evening breeze would catch the train of the dress, causing it to inflate like a spinnaker. His shutter clicked endlessly, and on the Sunday following the gala, there was Alexandra in Bill's "Evening Hours" page with Fe Fendi, photographed among the foliage of the conservatory. Little did I know that another wonderful picture of Alexandra alone would also run, in Bill's annual recap of the best dresses of the previous year. And imagine my surprise when I received this email from John Kurdewan on Tuesday afternoon, June 11, 2013:

Steven
Bill wanted to send you [a photo of]
this dress.
Thanks,
John

The message was accompanied by Bill's image of Alexandra in my dress (*opposite*). And that was the start of the beautiful friendship that resulted in this book. ∎

AFTERWORD

JOHN KURDEWAN

WHEN FRANCE AWARDED Bill with the *Ordre National des Arts et des Lettres* in 2008, he brought the entire audience assembled at the Musée des Arts Décoratifs (and himself) to tears with this line from his acceptance speech: "The only thing . . . to always believe is that 'he who seeks beauty will find it.'"

For Bill, that beauty was found in the clothes: "The cut, the silhouette, the color. It's the clothes. Not the celebrity and not the spectacle," he said. And that's the real takeaway—that in order to truly appreciate fashion as a reflection of the human existence, it needs to be viewed in the purest sense, without any bias as to who the wearer might be. He was quoted many times that he cared nothing for celebrity, especially celebrities who would appear in borrowed dresses. Bill was unflappable when it came to his view of the commerce of fashion. He believed that if a dress was not purchased and worn, no matter how beautiful, it wasn't a completely successful design. This is why identifying specific trends on the street or on the high-society circuit delighted him so. He lived for these random encounters, because they validated his extraordinary instinct for fashion. He knew what was good, and what was going to be great.

This absolute surety in his vision was in direct opposition to Bill's overwhelming sense of modesty, yet remained a part of his elusive charm. Throughout his life, Bill embodied the roles of both student and teacher simultaneously, often marveling at his own discovery while gleefully sharing it, especially with his colleagues. It was as if he wanted others to experience the joy that he himself was feeling.

The ability to view fashion in such an objective manner was one of Bill's greatest gifts to me, and to the world. I look at work and life and the world around me in a completely different way than I did before working for Bill. I notice little things now—the way a woman's dress might be the same color as a nearby flower or how the shape of her coat might reference another object. I notice how young people—Bill's "kids"—are dressing and realize how wonderful it is to see unique expressions of style. Who would have thought that pink or blue hair would ever be considered ordinary? But the uncovering of so many fashion trends was thanks to Bill, who made it happen simply by documenting and discussing it with such delight. If Bill Cunningham noticed something, it was truly worth noticing. ▪

OPPOSITE *Bill Cunningham, New York City, 2015.*

First published in the United
States of America in 2021 by
Rizzoli International
Publications, Inc.
300 Park Avenue South
New York, New York 10010
www.rizzoliusa.com

Copyright © 2021 by
John Kurdewan and Steven Stolman
Foreword by Ruben Toledo

PUBLISHER Charles Miers
SENIOR EDITOR Philip Reeser
PRODUCTION MANAGER Alyn Evans
DESIGN COORDINATOR Olivia Russin
COPY EDITOR Victoria Brown
MANAGING EDITOR Lynn Scrabis

DESIGNER Sarah Gifford

ISBN: 978-0-8478-7003-5
Library of Congress Control Number:
2020941329

2021 2022 2023 2024 /
10 9 8 7 6 5 4 3 2 1

Printed and bound in Italy

Facebook.com/RizzoliNewYork
Twitter: @Rizzoli_Books
Instagram.com/RizzoliBooks
Pinterest.com/RizzoliBooks
Youtube.com/user/RizzoliNY
Issuu.com/Rizzoli

CREDITS

All images by Bill Cunningham / *The New
York Times* / Redux

except for those on the following pages:

13, 18–19, 24–25, 26–27, 40–41, 46–47, 60–61,
74–75, 92–93, 100–01, 110–11, 114–15, 120–21,
128–29, 136–37: Bill Cunningham © 2021 *The
New York Times*

9: Gareth Cattermole / Getty Images

10, 139: © Diana DiMenna

15 (*top*), 16 (*bottom right*), 23 (*top*), 143:
© Chris Kahley

15 (*center left and right*), 16 (*top, center left,
and bottom*), 23 (*center*): © John Kurdewan

15 (*bottom*): © Tony Cenicola

21: © Terry Doktor

22: © The Estate of Antonio Lopez and
Juan Ramos

23 (*bottom*): © Melanie Tinnelly

144: © Steven Stolman

ACKNOWLEDGMENTS

The authors wish to thank all
of the wonderful people who
helped make this book possible:

Alexander Smith
Alexandra Lebenthal
Alina Cho
Blair Clarke
Charles Miers
Chelsea Zalopany
Crystal Henry
Devon Caranicas
Diana DiMenna
Fern Mallis
Gregory Miller
Hanneli Mustaparta
Heidi Rosenau
Jeffrey Banks
Joe Bird
Laura Hall
Laura Lofaro Freeman
Louise and Terry Doktor
Marilyn Kirschner
Pamela Fiori
Paul Caranicas
Philip Reeser
Rich Wilkie
Sam Sifton
Sarah Gifford
The Art Department of the
 New York Times
The New York Times Company

and, of course, Bill Cunningham

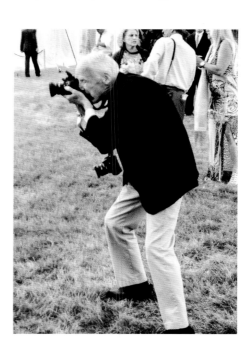